READY TO PAINT

New York
in Watercolour

Geoff Kersey

SEARCH PRESS

First published in Great Britain 2010

Search Press Limited
Wellwood, North Farm Road,
Tunbridge Wells, Kent TN2 3DR

Text copyright © Geoff Kersey, 2010

Photographs by Roddy Paine Photographic Studios

Photographs and design copyright © Search Press Ltd. 2010

ISBN: 978-1-84448-472-0

The Publishers and author can accept no responsibility for any
consequences arising from the information, advice or instructions given
in this publication.

Suppliers
If you have any difficulty obtaining any of the materials and equipment
mentioned in this book, please visit the Search Press website:
www.searchpress.com

Publisher's note
All the step-by-step photographs in this book feature the author,
Geoff Kersey, demonstrating watercolour painting techniques.
No models have been used.

You are invited to visit the author's website at
www.geoffkersey.co.uk

Please note that when removing the perforated sheets of tracing paper
from the book, score them first, then carefully pull out each sheet.

Printed in China

Page 1
City Hall Park, Manhattan
31 x 46.5cm (12¼ x 18¼in)

*Right in the middle of the bustle of the New York streets on a packed
Saturday afternoon, I found this oasis of greenery. I like the way the
red brickwork of the offices is just glimpsed between the full summer
foliage. I carefully masked out the figures and the spouting water
right at the outset, then did a bit of spattering, also with masking
fluid, to suggest the splashing water of the fountain.*

Opposite
Looking Towards the Chrysler Building
56 x 76cm (22 x 30in)

*A book on painting New York would not be complete without
the Chrysler Building. I love the series of diminishing semicircles
featured in the Art Deco design of the top. Because you can see this
iconic landmark from so many angles and from so many different
streets, the most difficult decision I faced was which view to use.
I was particularly attracted to the juxtaposition of the soft shapes
of the trees at the bottom of the tall, angular buildings and the
opportunity these rich, dark greens gave me to highlight the bright
yellow colour of the New York taxis, of which, I read, there
are an incredible 13,000.*

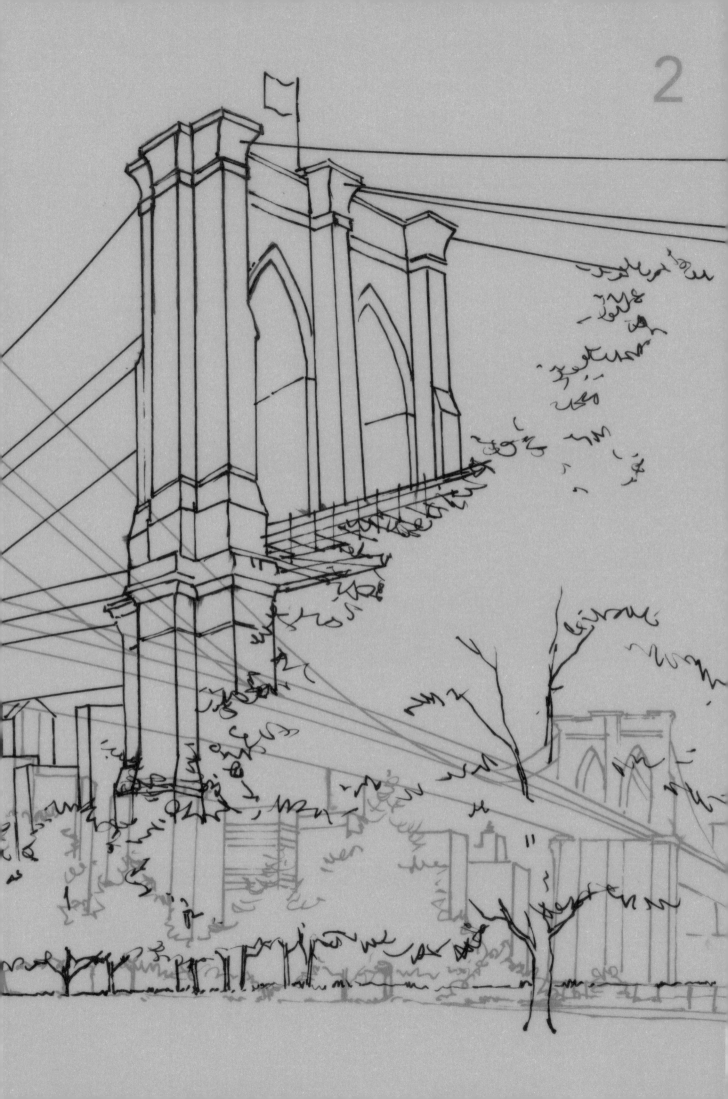

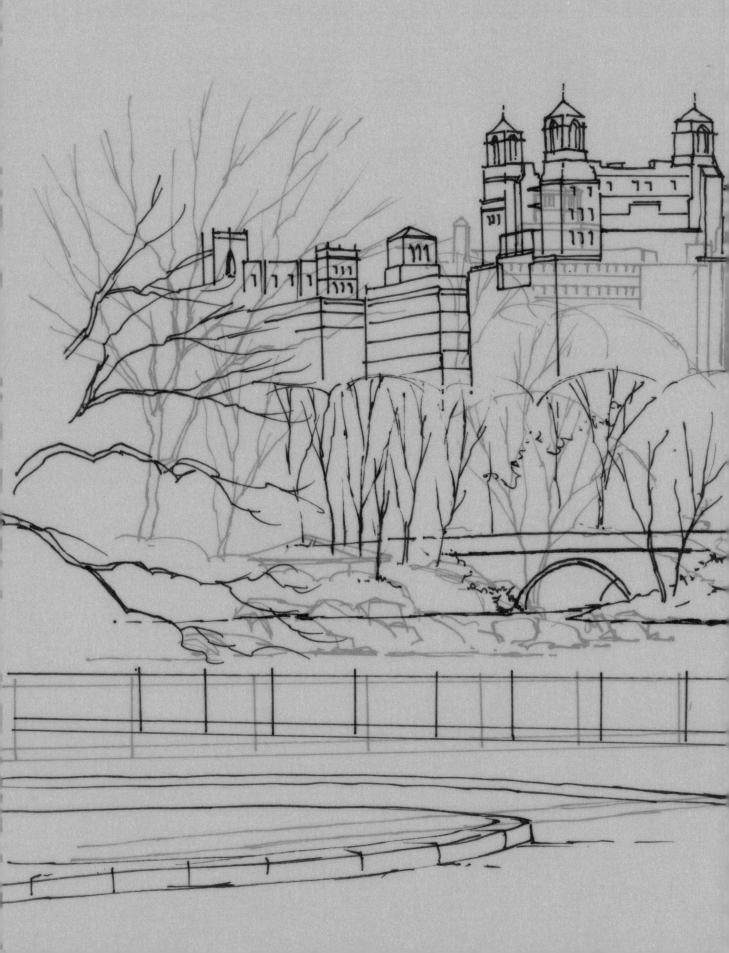

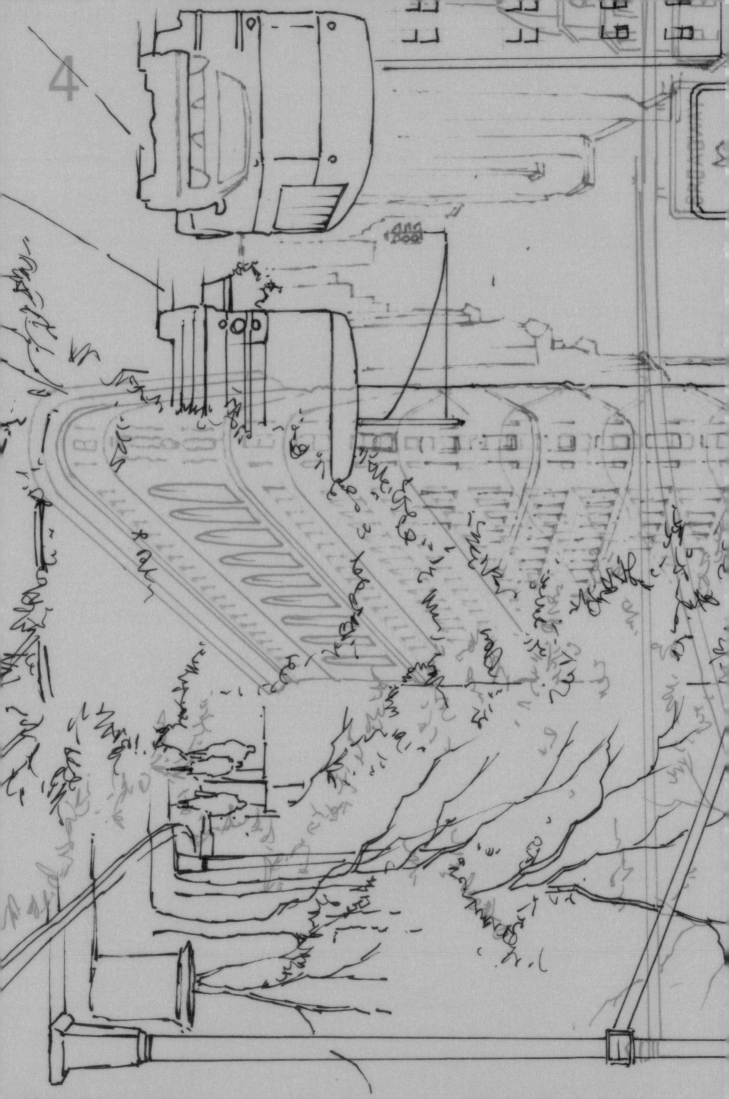

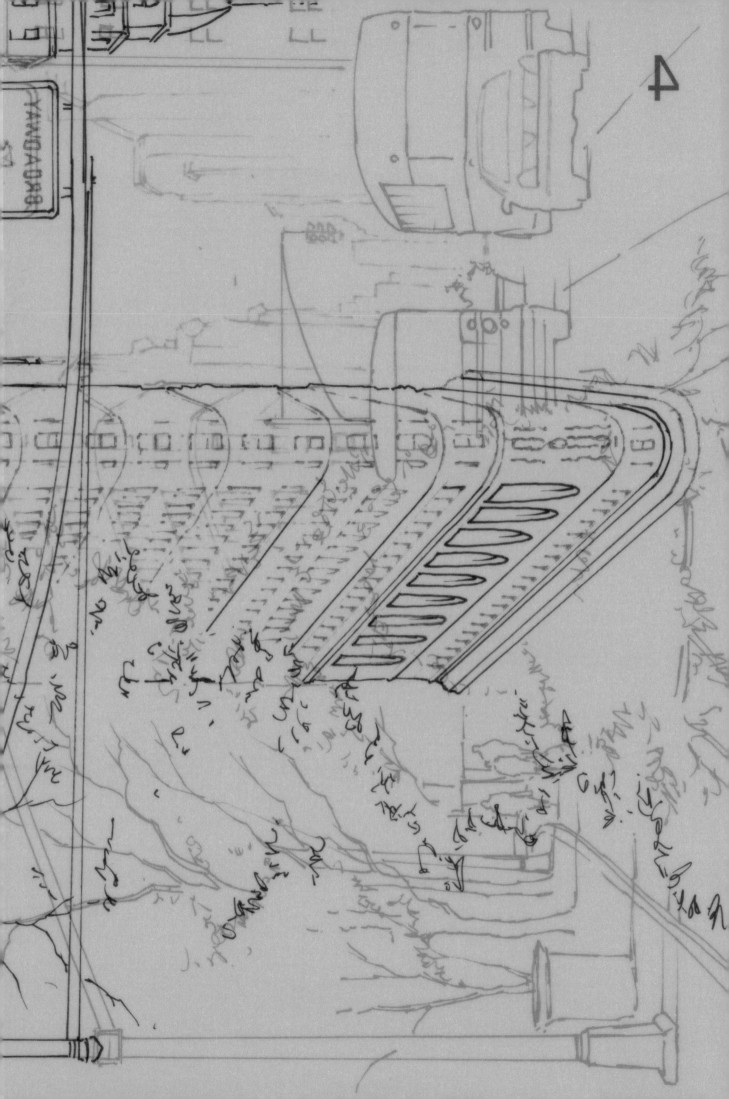

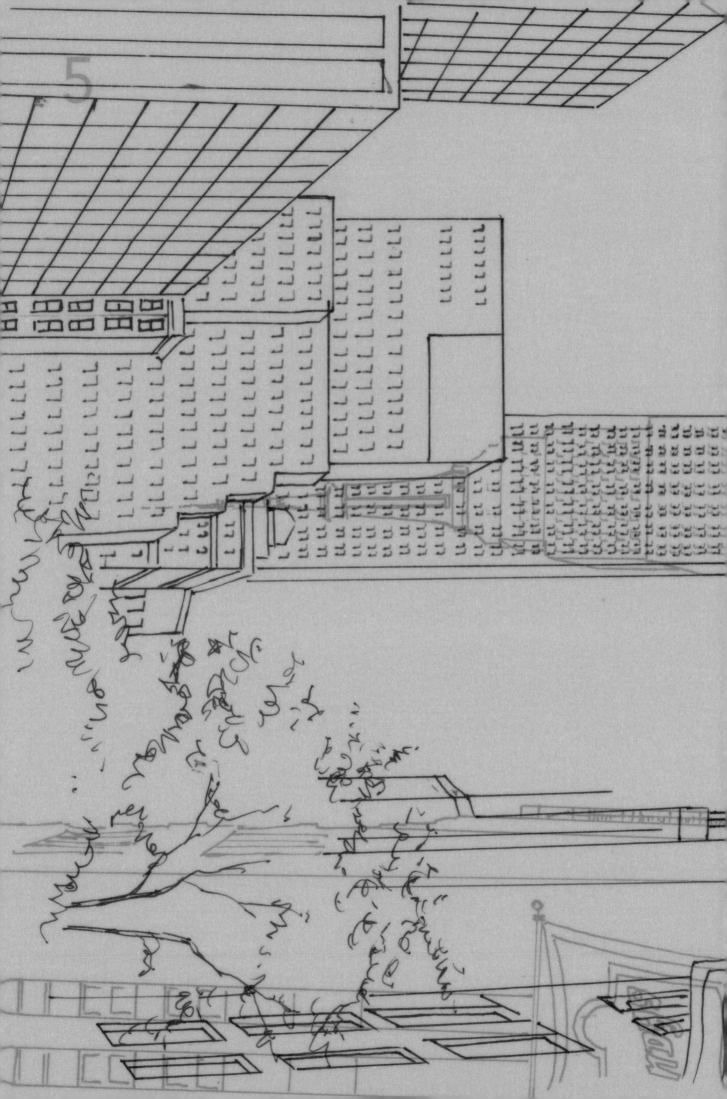

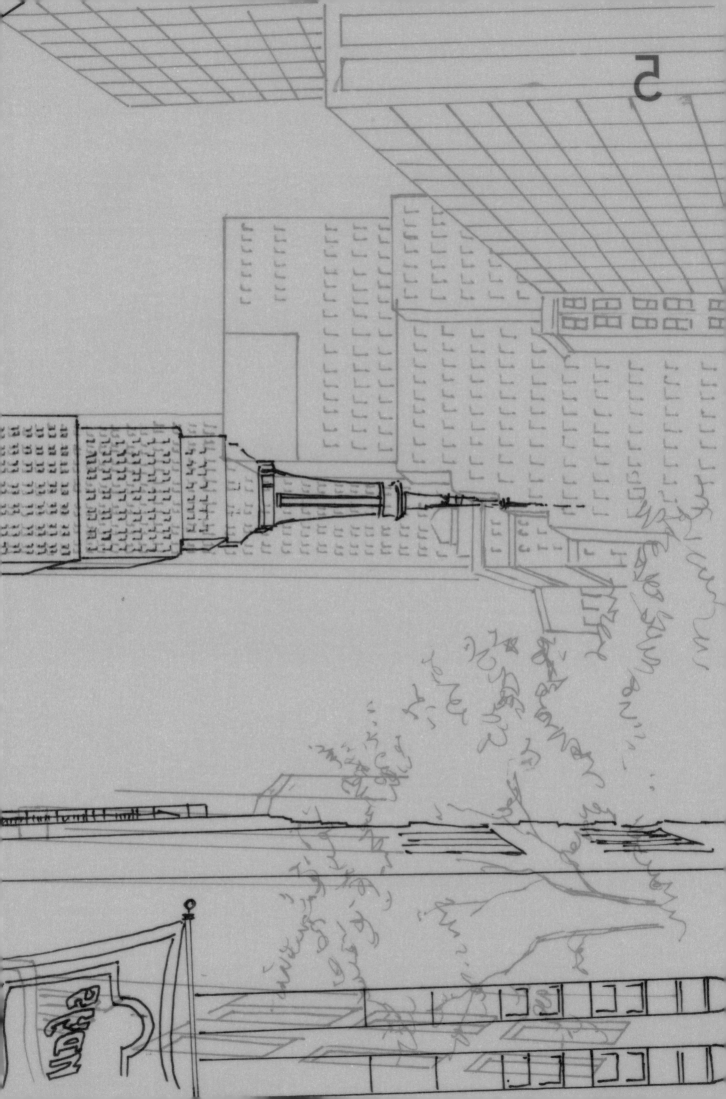

6

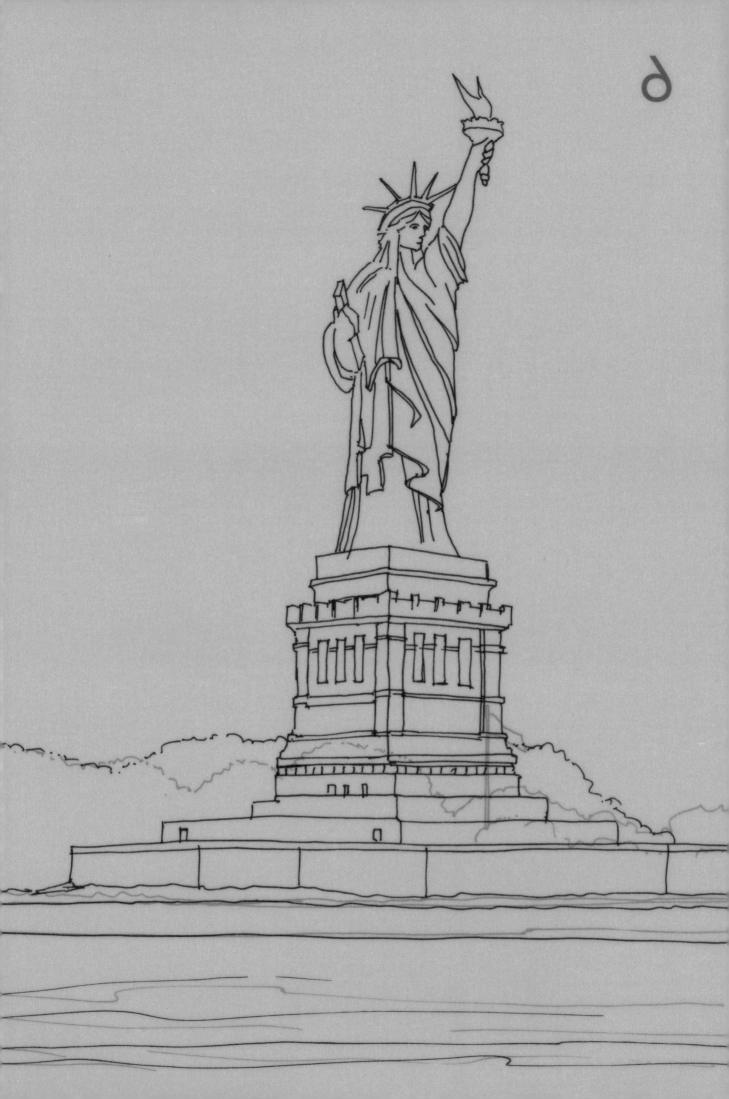

Contents

Introduction

Although my wife Florence and I had discussed going to New York several times, we had never got round to it, so being offered the opportunity to write this book was just the spur we needed.

There are various ways to get available photographs of iconic city scenes, but I believe that to approach a subject like this with any sort of conviction and confidence, one needs to have actually been there and walked the streets, taking in the atmosphere, sights and sounds, appreciating the sheer scale of everything and the full-on hustle and bustle of the place. So flights and a hotel were hurriedly arranged and we were on our way. We were bowled over by the city and on my return I could not wait to get going on painting some of the inspiring subjects we had seen.

The first two paintings I did were full imperial size, 56 x 76cm (22 x 30in), these were *Jogger, Manhattan* (opposite) and *Looking Towards the Chrysler Building* (on page 3). These gave me a feel for the subjects and a method of approach for the subsequent projects featured here. For these five step-by-step projects, I have chosen some of the most iconic scenes of New York. I felt that they required the inclusion of quite a lot of detail, not just on the buildings themselves but the street furniture, cars, foliage and figures. This makes the tracings provided particularly appropriate and very useful. However, do not feel you have to stick too rigidly to the tracings and instructions – it may be that you would like to make changes, adding or removing figures or cars or trying different colour combinations and mixes.

I hope you enjoy trying out what are, for me, new and exciting subjects, as much as I enjoyed both the research and the actual painting process.

Jogger, Manhattan
56 x 76cm (22 x 30in)

I tried with this, my first New York painting, to capture the feeling of the figures and cars being totally dwarfed by the sheer height of the buildings. I used cool greys for the more distant sky scrapers, gradually adding a touch of warmth to the nearer ones.

Often it is quite a small element in a scene that catches my eye initially, and in this case it was the bright light reflecting on the striped parasol, compared to the darks from the deep shadows created by the surrounding architecture.

I was unsure at first whether or not to include the jogger, but I am pleased I did, as I feel she lends scale to the whole scene and, with her front foot off the ground, adds a touch of movement.

Map of New York with project sites marked

This map of New York shows the sites of the five step-by-step projects in this book marked in red: **A** *Brooklyn Bridge,* **B** *Central Park,* **C** *the Flatiron Building,* **D** *the Empire State Building and* **E** *the Statue of Liberty.*

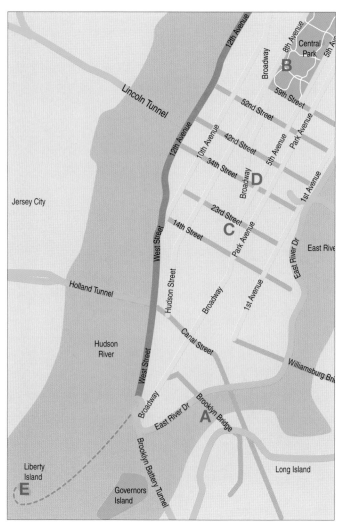

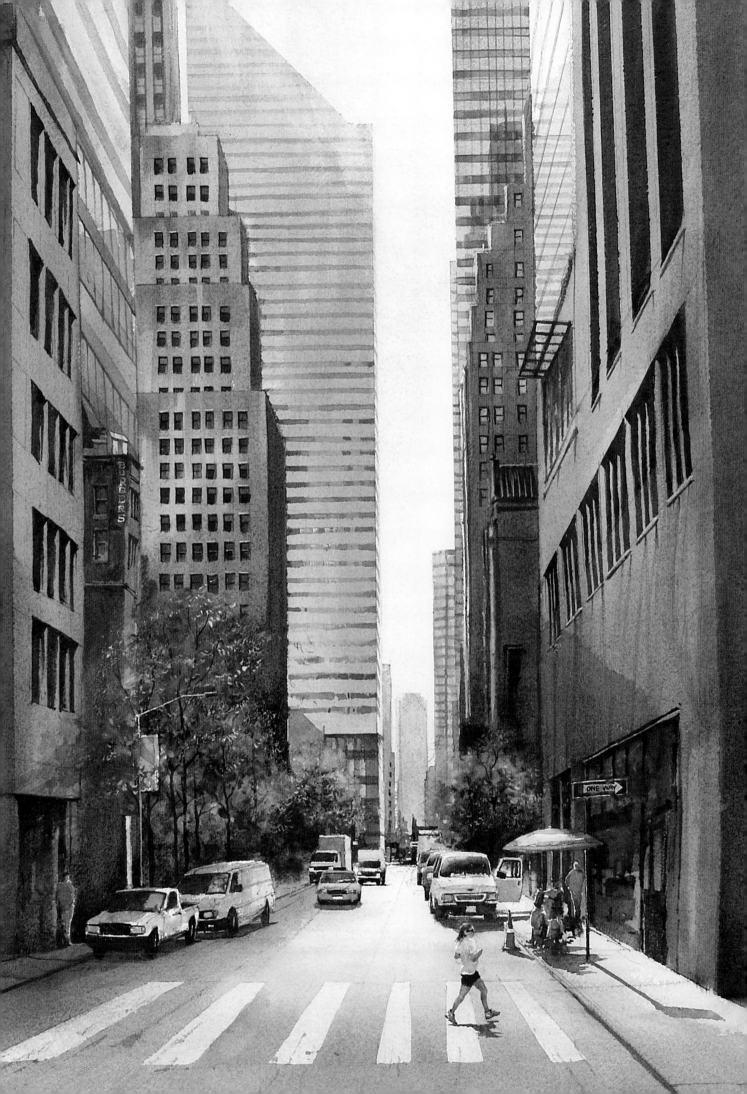

Materials

Paints

Watercolour paints can be bought in either artist or student quality. Student quality paints have improved, but I still recommend artist quality, as the paints have a greater ratio of pigment to gum, producing brighter, richer results and making the paints go further.

You can buy watercolours in pans or tubes, but I prefer tubes, as the paints are semi-liquid and it is therefore quicker and easier to mix washes. I squeeze the paints into the wells of my palette before beginning to paint.

My basic palette includes cobalt blue, cobalt violet, lemon yellow, aureolin, French ultramarine, burnt sienna, burnt umber, raw sienna, rose madder, Naples yellow, viridian, cobalt turquoise, light red and quinacridone gold. I use touches of white gouache when I need a little opaque colour.

Artist quality watercolour paints in tubes.

Paper

There are three types of paper surface: HP (hot pressed, or smooth), Not (cold pressed, or medium) and Rough. I prefer Rough paper for landscape painting as it has a 'tooth' that allows you to achieve some dry brush effects. This is particularly useful when depicting trees and foliage. However, for paintings with lots of architectural detail, Not paper is preferable, as it still has some texture, but allows you to capture finer details.

Look for good brands of paper and do not buy anything lighter than 300gsm (140lb), as it will cockle when wet. Even when using this weight, it is best to stretch the paper. Immerse it in water for a minute, lay it flat on a painting board and leave it for a few minutes. It will expand, so pull it flat and secure it with gummed tape or staples. The paper contracts as it dries and creates a flat surface.

For all the projects in this book, I used 56 x 38cm (22 x 15in) sheets of 300gsm (140lb) Not watercolour paper. The paintings do not fill an entire sheet.

Brushes

I use mainly synthetic brushes, apart from one large mop brush.

Most of my landscape painting is done with round brushes and just a couple of flat brushes. However, this book features many quite detailed buildings, and for architectural details such as windows, I found that flat brushes were particularly useful.

Make sure that your round brushes all have good, fine points. Once the points wear out, you should replace the brushes, or use them for applying masking fluid or for techniques like scumbling and dry brush work.

The brushes I used for the step-by-step demonstrations in this book are shown below. They are, from left to right, a no. 1 round, no. 2 round, rigger, no. 3 round, 3mm (⅛in) flat, 6mm (¼in) flat, no. 7 round, no. 8 round, 10mm (⅜in) flat, no. 10 round, 2.5cm (1in) flat, no. 18 round and a large mop brush.

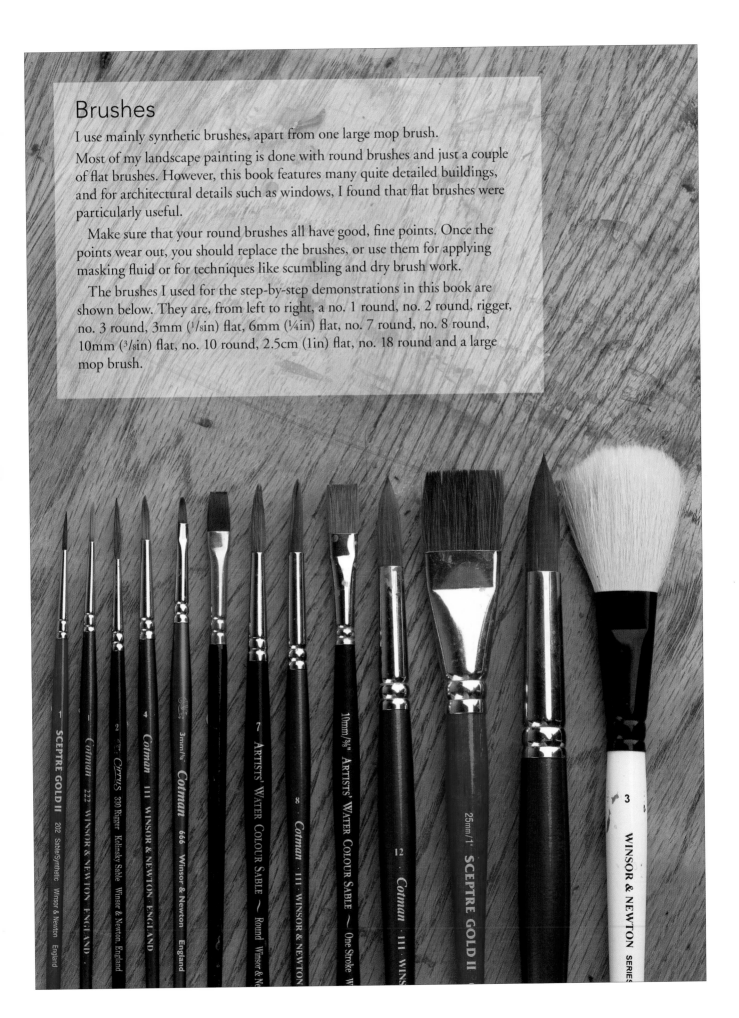

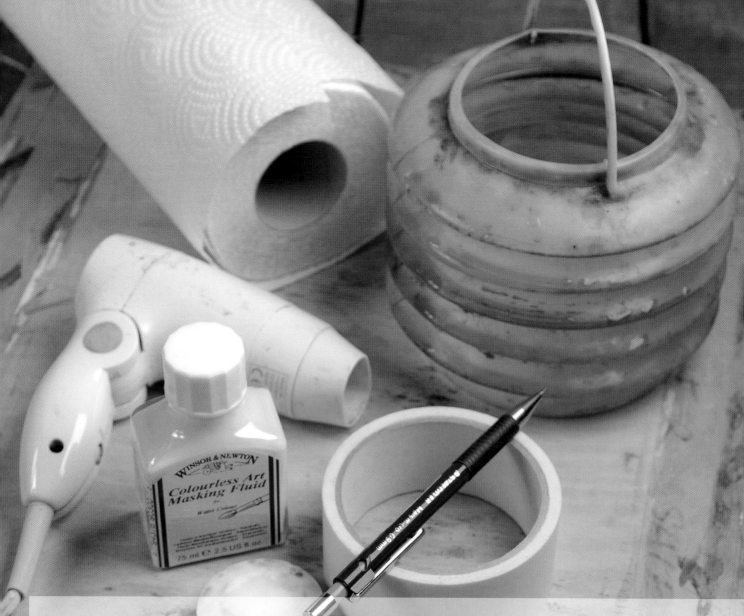

Other materials

Stretch your watercolour paper on a **painting board**. I use some made from 13mm (½in) plywood and others made from MDF.

Kitchen paper can be used to lift out colour or to help remove errors.

I use a collapsible **water pot** as it takes up less space when I am carrying around my painting equipment.

Masking tape can be used to mask off the edges of your painting area. When removing it, pull it away from the painting area to avoid tearing your work. It can also be used to help you paint straight edges, as in the Empire State Building project on pages 34–41.

A mechanical **pencil** is useful for transferring a tracing to your watercolour paper.

Masking fluid is used to mask off areas of a painting that you want to keep white. Dampen the brush first and coat it with **soap** before dipping it into masking fluid. The masking fluid will then wash out easily after use.

Clockwise from top left: kitchen paper, a collapsible water pot, masking tape, a mechanical pencil, soap, masking fluid and hairdryer, all on a painting board. Inset, from top to bottom: flexible French curve, set square and ruler.

A **hairdryer** can be used to speed up the drying process if you are in a hurry. I prefer to allow washes to dry naturally, as the colours continue to flow into one another on the paper as they dry.

A **set square** is used to ensure that lines are perpendicular where necessary.

A **ruler** is used to help you to paint straight lines where necessary.

A **flexible French curve** is used to help you paint curved lines.

Transferring the image

Tracings are provided at the front of this book for all the demonstration paintings. Follow the steps shown below to transfer the images on to watercolour paper. You can reuse each tracing several times so you can use the same basic image to produce two quite different paintings.

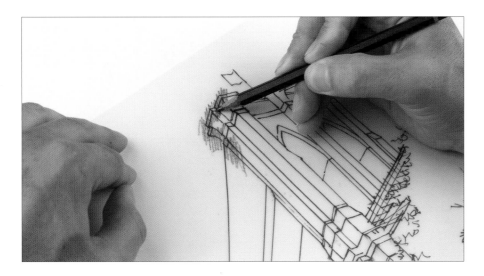

1 Place the tracing face-down. Scribble over the image area on the back using a 2B pencil. You will be able to reuse this tracing several times without repeating this step.

2 Tape a sheet of watercolour paper to a board and place the tracing, face-up, on top. Now tape down the tracing. Draw carefully over the lines of the tracing with a pencil. I have used a mechanical pencil so that I do not have to keep sharpening it.

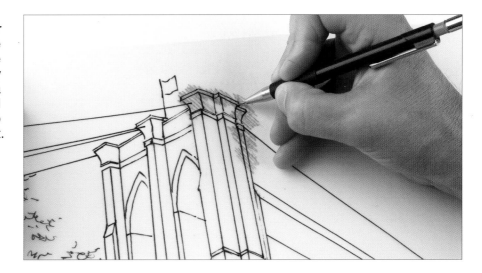

3 As you work, lift up the tracing to see how the transfer of the image is going.

Brooklyn Bridge

This is an incredible structure, but where to go to get the best view? In the end I chose this one, looking back at the bridge from the Fulton Ferry terminal. To reach it, we walked across the bridge on the footpath, with its memorable views of Manhattan to one side and the port with Staten Island and the Statue of Liberty to the other side. The inclusion of the distant sky scrapers glimpsed under the bridge is important as this emphasises the bridge's sheer scale. However I have treated them as fairly simple, toned down shapes, so as not to distract from the main subject.

Tip

Always read a few steps ahead and prepare all the washes you will need for the next section of the painting in advance.

You will need

300gsm (140lb) Not watercolour paper, 56 x 38cm (22 x 15in)

Brushes: 2.5cm (1in) flat, no. 16 round, 6mm (¼in) flat, 3mm (⅛in) flat, no. 4 round, no. 8 round, no. 1 round, no. 10 round, no. 2 round

Colours: Naples yellow, light red, cobalt blue, rose madder, raw sienna, burnt sienna, French ultramarine, lemon yellow, aureolin, viridian, white gouache, cadmium red

Masking fluid and old brush

French curve

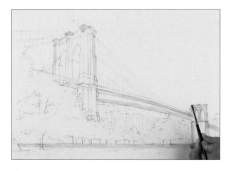

1 Apply masking fluid to the main towers, the bridge itself and the line where the buildings meet the grass. Prepare all the washes you will need for the sky and the distance.

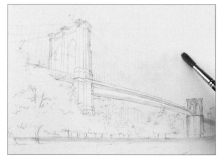

2 Wet the whole sky with a 2.5cm (1in) flat brush and clean water. This includes the glimpse of sky beneath the bridge. Take the no. 16 round brush and paint a thin wash of Naples yellow and light red in the lower part of the sky.

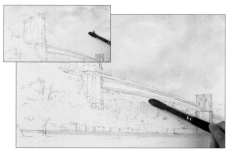

3 Clean the brush and drop in a mix of cobalt blue and rose madder from the top of the sky, leaving gaps for clouds. Add a little more rose madder lower down and leave to dry.

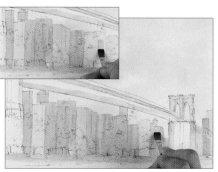

4 Use a 6mm (¼in) flat brush to put in simple shapes for the distant buildings with a thicker mix of Naples yellow and light red. Paint down to the foreground masking fluid and allow to dry.

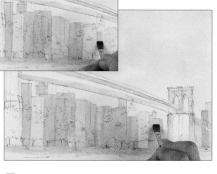

5 Paint other buildings with a mix of cobalt blue and rose madder, and go over some of the previous colour. Add more light red to the yellow mix and paint touches of this redder colour. Allow to dry.

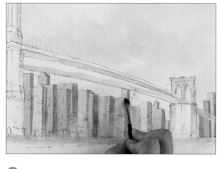

6 Mix cobalt blue, rose madder and light red for a shadow colour and use a 6mm (¼in) flat and a 3mm (⅛in) flat to shade the sides of buildings. The different sized brushes help to vary the depth of the buildings.

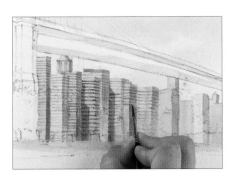

7 Use the no. 4 round brush to paint horizontal lines suggesting windows with the same grey mix. Vary the intensity by adding more or less water. Details should just be suggested, as the buildings are in the distance. Allow to dry.

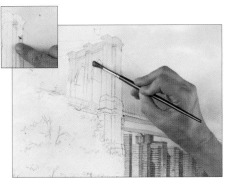

8 Remove the masking fluid from the foreground tower of the bridge, using a clean finger. Begin to paint the tower from the top with the no. 4 round and a mix of Naples yellow and light red. Change to the no. 8 round once you have painted the detailed edges.

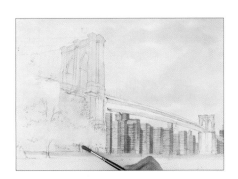

9 As you work down, introduce a mix of raw sienna and rose madder. Fade out with clean water where the trees will be, then add colour at the bottom. Allow to dry.

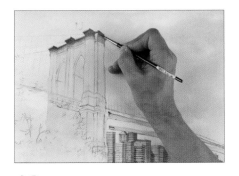

10 Use the no. 4 round and the grey mix of cobalt blue, rose madder and light red to paint shadows round the top of the tower. Fade the edges with clean water and allow to dry.

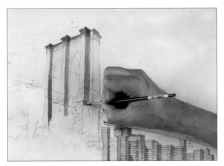

11 Paint the vertical shadows with a mix of cobalt blue and rose madder, and while this is wet, paint with the darker grey mix lower down.

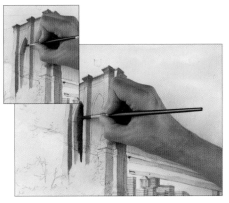

12 Paint the edges of the shadows in the arches with cobalt blue and rose madder. Change to the no. 8 brush and a darker wash of cobalt blue, rose madder and burnt sienna to paint the darker shadow inside.

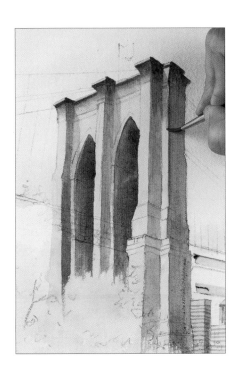

13 Use the no. 4 round to paint a cast shadow from the top of the tower with a thin wash of cobalt blue and rose madder.

14 Paint a dark shadow down the right-hand edge of the tower with a mix of cobalt blue, rose madder and burnt sienna.

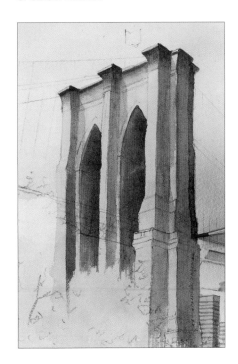

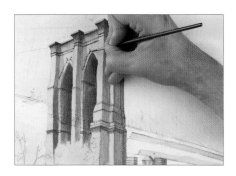

15 Take the no. 1 round brush and begin to paint the finer details of the tower with the cobalt blue, rose madder and burnt sienna mix.

16 Suggest the stones of the tower with the 3mm (1/8in) flat brush and a mix of Naples yellow and light red, then paint more stones in with a mix of cobalt blue and rose madder. Be aware of perspective and angles when painting stones.

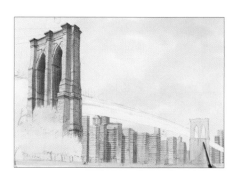

17 Remove the masking fluid from the rest of the bridge and paint the distant tower with the no. 4 brush and Naples yellow and light red, adding in raw sienna and rose madder lower down as before. Allow to dry.

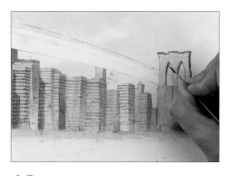

18 Using the no. 1 round brush, suggest a little detail with a mix of cobalt blue, rose madder and burnt sienna.

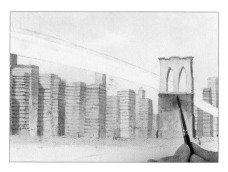

19 Paint a deep shadow in the lower half of the tower with the same mix, then fade it off with water at the bottom. Add more colour at the top to deepen the shadow.

20 Add suggested details with the no. 1 brush. They should be kept simple since this tower is much further in the distance than the other one.

21 Looking ahead, prepare all the washes you will need for the walkway and trees. The underside of the walkway should be painted with the strongest tone yet, so mix French ultramarine, burnt sienna and a little rose madder and paint the left-hand side with the no. 4 brush.

22 While this is wet, drop in lemon yellow to suggest the foliage in front of the bridge, and allow the colours to merge.

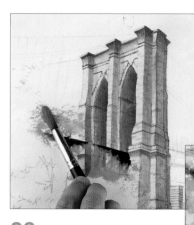

23 Still working into the wet paint, use the no. 10 round brush on its side and a bright green mix of aureolin and cobalt blue to create foliage. Then use pure lemon yellow on the no. 2 brush to pick out leaves against the dark of the walkway.

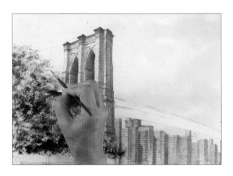

24 Add more bright green foliage, then, while this is wet, use the no. 8 round brush to apply a dark green mix of viridian, ultramarine and burnt sienna, allowing the greens to blend. Use the no. 2 brush to pick out the edges of the foliage in bright green.

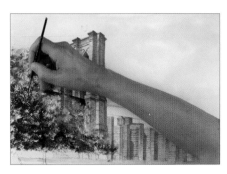

25 Use the no. 1 brush and the dark mix of burnt sienna, ultramarine and rose madder to paint the branches glimpsed in the gaps between the foliage.

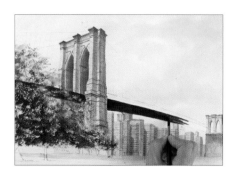

26 Change to the no. 4 brush and use the same mix to emphasise the dark of the bridge behind the trees, then extend the dark walkway across the painting. Once you have painted the edges, change to the no. 8 brush to paint the central area.

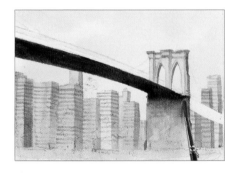

27 Paint a shadow under the walkway using a mix of cobalt blue, rose madder and light red and use a damp, clean brush to soften it. Allow to dry.

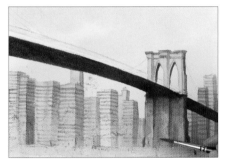

28 Paint shadows in the recesses under the arches in the same way, then emphasise them on the left-hand side with a stronger mix.

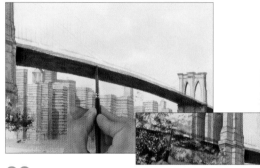

29 Suggest the mass of steelwork at the edge of the bridge with the same grey mix. Extend this behind the tree on the left in the same way.

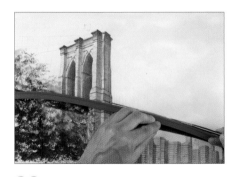

30 Use the flexible French curve to help you paint the horizontal steelwork without wobbling. Ensure you have the shape of the curve exactly right by checking it against the tracing before you apply any paint. Use the no. 2 brush and the same grey mix and paint one curve for the top of the railing, then a parallel curve beneath it.

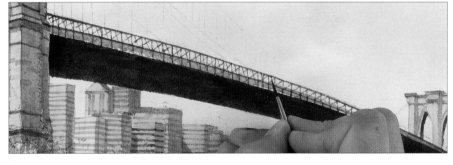

31 Paint in the verticals and diagonals of the steelwork freehand with the same brush and mix.

32 Paint the supsension cables with the French curve as in step 30.

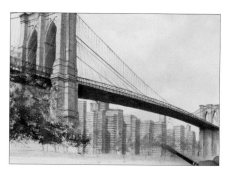

33 Thin the grey mix with water and use a fairly dry brush to paint the vertical cables with rapid downward strokes. Paint the finest diagonals in the same way.

34 Add white gouache to the grey mix to paint the fine cables where they cross the dark shadows in the arches.

35 Prepare your paint mixes for trees in advance. Paint the trees on the right-hand side with the no. 8 brush on its side and a bright green mix of aureolin and cobalt blue.

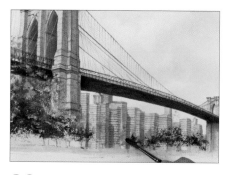

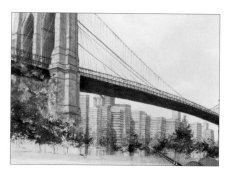

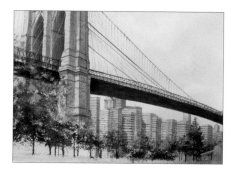

36 While this is still wet, paint a dark green mix of viridian, ultramarine and burnt sienna over the top.

37 Change to the no. 4 brush and paint lemon yellow on the left-hand, sunlit sides of the trees.

38 Paint the tree trunks with the no. 2 brush and burnt sienna mixed with ultramarine. Allow to dry.

39 Suggest the distant structures behind the left-hand trees using the 6mm (¼in) flat brush and a mix of Naples yellow and light red. Allow to dry.

40 Suggest shadow on the distant structures with a mix of cobalt blue, rose madder and light red.

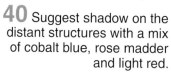

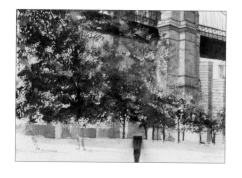

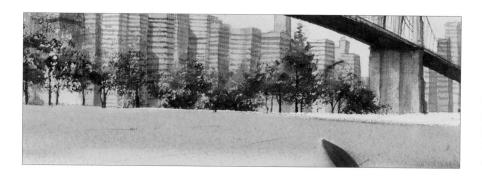

41 Remove all the remaining masking fluid. Use the no. 16 brush to paint the foreground grass with a bright green mix of aureolin and and cobalt blue.

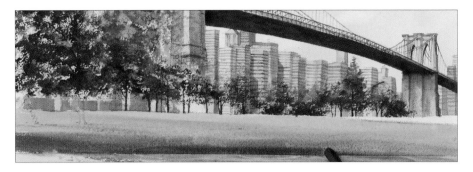

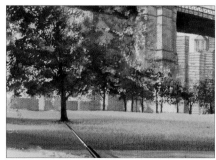

42 Paint a shadow across the front of the foreground with the no. 10 brush and a mix of viridian, ultramarine and burnt sienna. Allow to dry.

43 Mix burnt sienna, ultramarine and rose madder and use the no. 4 brush to paint the foreground tree trunk and branches. Soften the trunk into the ground with the no. 2 brush and aureolin with cobalt blue.

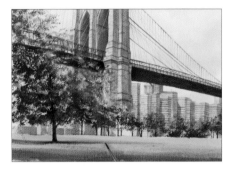

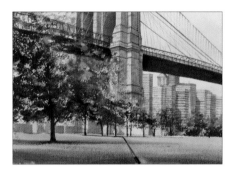

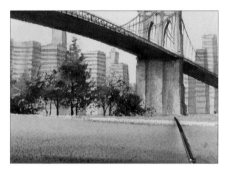

44 Using the no. 4 brush and the dark green used in step 42, paint a cast shadow from this tree.

45 Use a clean, damp brush to soften the trunks of the distant trees into the grass. Then paint cast shadows in dark green as before.

46 Mix cobalt blue and rose madder to match the sky and paint this in the strip of river.

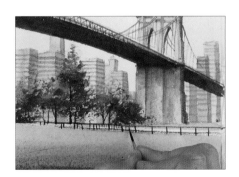

47 Paint the railings on the right with the no. 2 brush and a dark mix of burnt sienna, ultramarine and rose madder.

48 Paint the flag's stripes with cadmium red and the no. 1 brush. Add shadow with a mix of rose madder and cobalt blue. Paint the blue part with ultramarine.

49 Paint the flag pole with cobalt blue, rose madder and burnt sienna.

Overleaf

The finished painting.

15

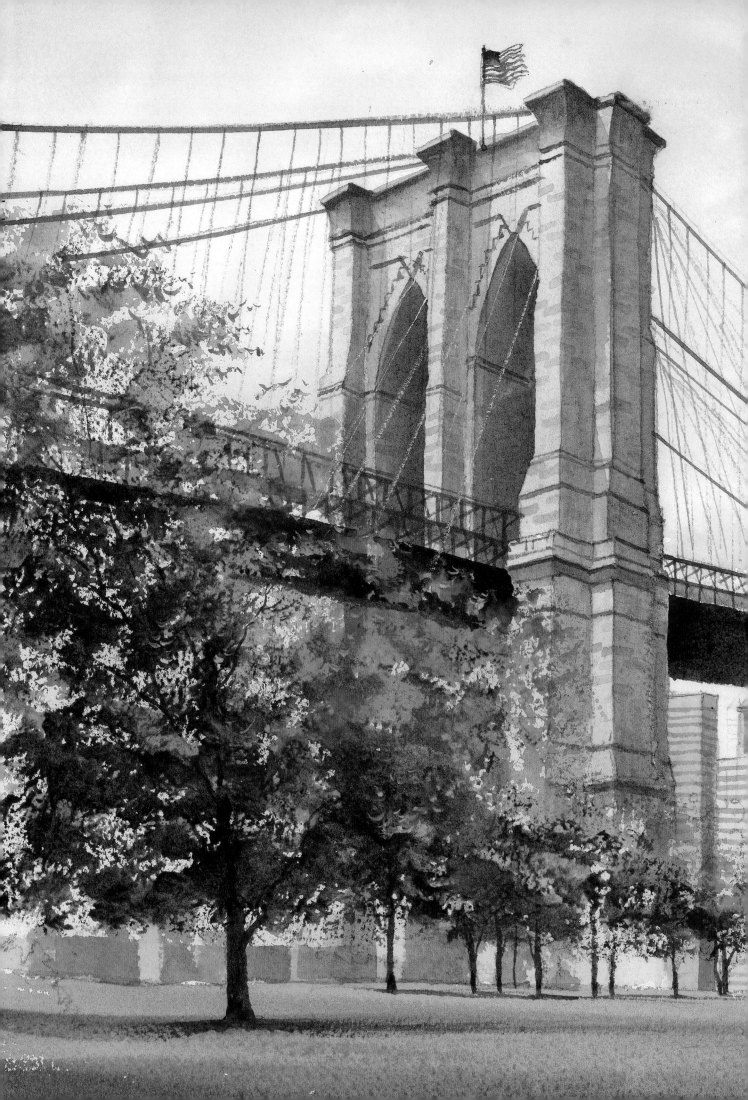

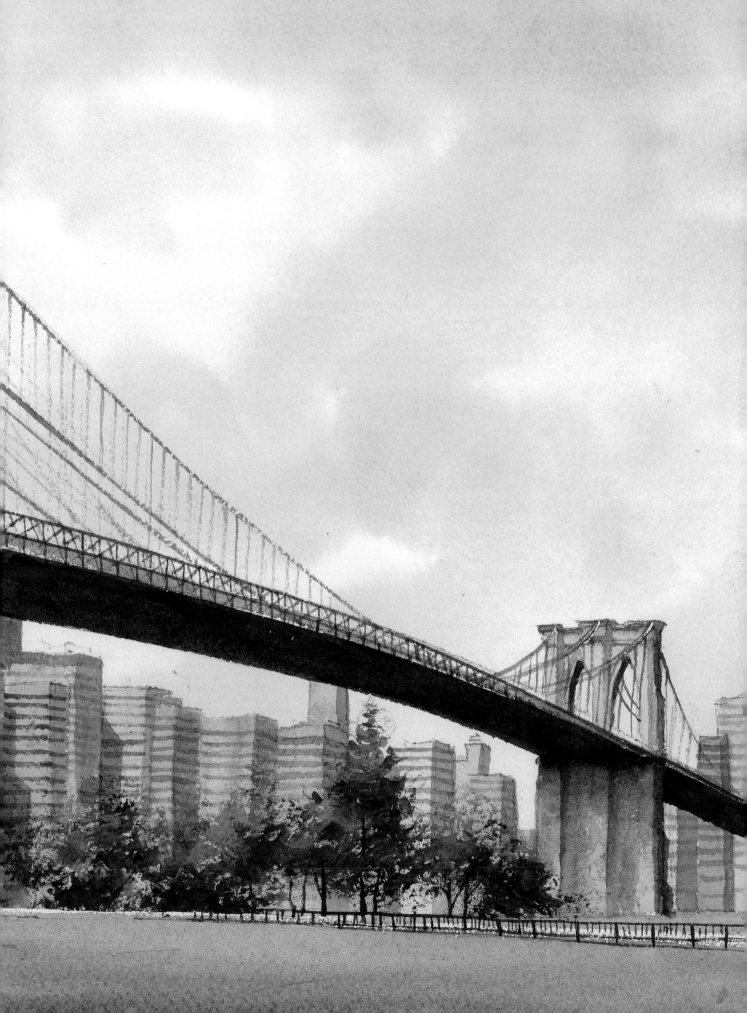

Central Park in Winter

As with the other Central Park painting on page 48, I particularly liked the mixture of soft landscape represented by the park with its old, stone bridge, rugged rocks, trees and reflections in the lake, contrasted with the buildings of the Upper West Side glimpsed in the distance. These were deliberately rendered in paler tones and cooler colours to create the impression of distance.

TRACING
3

You will need

300gsm (140lb) Not watercolour paper, 56 x 38cm (22 x 15in)

Colours: Naples yellow, rose madder, cobalt blue, raw sienna, light red, cobalt turquoise, lemon yellow, burnt sienna, aureolin, French ultramarine, white gouache

Brushes: 2.5cm (1in) flat, no. 16 round, 10mm (³⁄₈in) flat, no. 1 round, no. 4 round, 6mm (¼in) flat, no. 2 round, 3mm (¹⁄₈in) flat no. 7 round, no. 8 round, rigger, no. 10 round

Masking fluid and old brush

Craft knife

Tip
Prepare all the washes you will need for the next section of the painting in advance, especially when you are applying washes quickly, while the previous one is wet.

1 Use masking fluid to mask the tops of the buildings, the top of the bridge, the gazebo roof, the rocks and below the water's edge.

2 Wet the sky area with the 2.5cm (1in) flat brush, then use the no. 16 round and a thin mix of Naples yellow and rose madder to paint the lower part of the sky.

3 Paint a thicker mix of cobalt blue and rose madder from the top, then add more of the pinkish mix. Allow to dry.

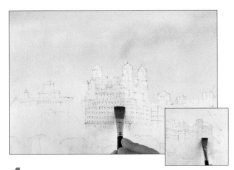

4 Remove the masking fluid from the buildings with a clean finger. Paint a thin wash of Naples yellow and rose madder over the buildings with the 10mm (³⁄₈in) flat brush. Paint a mix of raw sienna and light red on to parts of the building that need to look warmer.

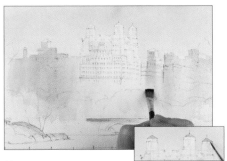

5 Paint a mix of cobalt blue and rose madder on top of the first wash to suggest shadow. Allow to dry. Mix cobalt turquoise with lemon yellow and use the no. 1 round brush to paint the verdigris on top of the towers.

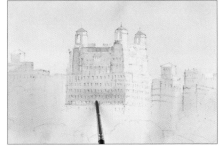

6 Paint shadow on the central building with the no. 4 brush and cobalt blue with rose madder. Add a little Naples yellow and rose madder to warm it lower down.

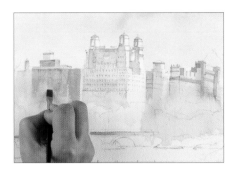

7 Continue adding structure to the buildings using the same two mixes. Then change to the 6mm (¼in) flat brush and drag cobalt blue and rose madder down the building on the left. Allow to dry.

8 Change to the no. 2 round brush and use a darker mix of cobalt blue, rose madder and light red to paint details on the central building. Use the 3mm (⅛in) flat brush to paint windows with little downward strokes.

9 Use the no. 1 brush to paint the windows on the lit face of the building, then use the no. 4 brush for larger details.

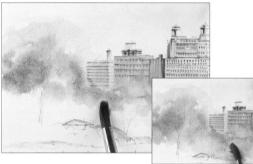

10 Add burnt sienna to the mix to darken it and continue adding details on the left-hand side of the central building with the no. 1 and no. 4 round brushes. Allow to dry.

11 Prepare the washes for the next stage of the painting as you will be working quickly, painting wet into wet washes. Apply a wash of Naples yellow and rose madder into the left-hand tree area with the no. 16 round brush.

12 Add clear water, then drop in a mix of cobalt blue, rose madder and light red while the first wash is wet. Drop in more Naples yellow and rose madder, still working wet into wet.

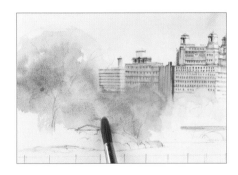

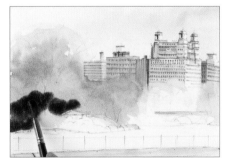

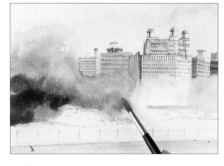

13 Before the paint dries, drop in raw sienna and light red.

14 Wet the area down to the masking fluid with clean water and drop in a mix of burnt sienna and cobalt blue.

15 Using the no. 7 brush, drop in aureolin and cobalt blue and let it merge with the wet paint.

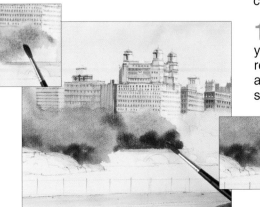

16 Wet the base of the buildings with clean water and float in Naples yellow and light red, then the grey mix of cobalt blue, rose madder and light red. While this is wet, drop in raw sienna and light red, then burnt sienna and cobalt blue at the top of the bridge, to provide contrast so that it will stand out. Soften the edge to the left of the bridge with clean water.

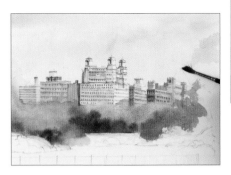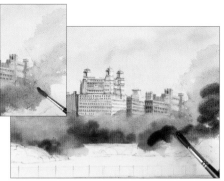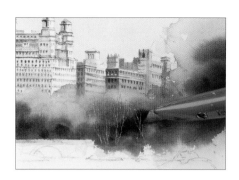

17 To paint the trees on the right, paint on a thin wash of Naples yellow and light red.

18 Using a no. 8 brush, drop in raw sienna and light red to warm the area. Wet down to the base with clean water. Drop in the grey mixed from cobalt blue, rose madder and light red, then dark brown mixed from burnt sienna and cobalt blue.

19 When the paint is almost (but not quite) dry, scratch out lighter trees against the dark brown using a craft knife. It is a good idea to practise this scratching out technique on a separate piece of paper first. Allow to dry fully.

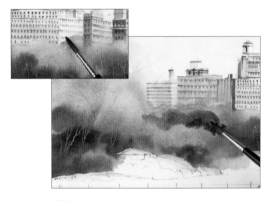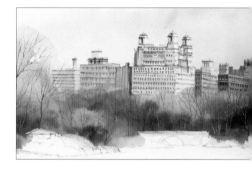

20 Use a damp, clean no. 7 brush to soften any hard-edged areas of trees. Dab them with kitchen paper to lift out colour. I also noticed an area that needed to be darker, so I wet it and dropped in grey and then dark brown. Allow to dry.

21 Use a rigger brush and a strong mix of burnt sienna and ultramarine to paint trunks and branches, starting from the left-hand side.

22 Continue across the painting, creating branchwork in the same way. Change to the no. 1 brush to extend the scratched out trees where they are dark against light.

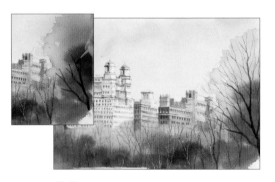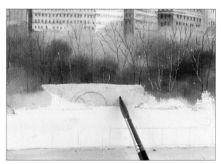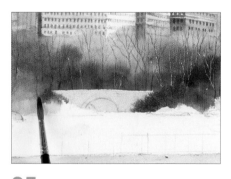

23 Paint the trunk and branches of the large tree on the right with the no. 4 brush and the same mix, then change to the rigger to extend the branches out to the edges.

24 Prepare your paint mixes in advance for the bridge. Remove the masking fluid and use the no. 7 round brush to paint on a thin wash of Naples yellow and rose madder, leaving a thin white line at the top, then drop in a slightly thicker wash of raw sienna and light red.

25 Drop in burnt sienna and cobalt blue on either side of the bridge while the paint is wet, to soften the bridge into the wooded setting.

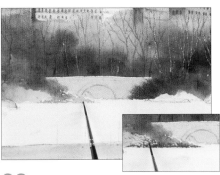 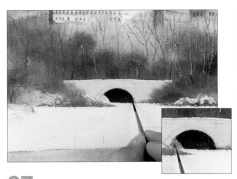 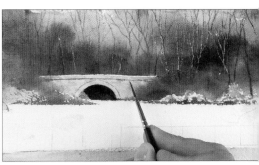

26 Use the no. 1 round brush to brush in a pale grey mix of cobalt blue, rose madder and light red to suggest the rocks at the water's edge. Allow this to dry, then use the brush on its side, scraping it across the surface, to paint a darker mix of the same colours on top.

27 Allow the bridge to dry, then take the no. 2 round brush and paint the archway with a dark mix of ultramarine and burnt sienna. Paint the background seen through the arch with cobalt blue, rose madder and burnt sienna.

28 Paint the bridge's detail with the ultramarine and burnt sienna mix, then suggest stones with cobalt blue, rose madder and burnt sienna.

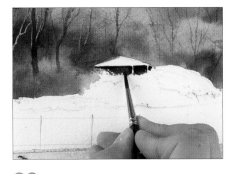 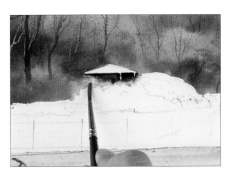 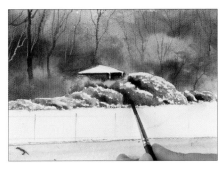

29 Remove the masking fluid from the left-hand side of the painting. Use the no. 4 brush to paint the dark under the roof of the gazebo with burnt sienna and ultramarine, leaving white to suggest the supports.

30 Paint the bush in front of the gazebo with raw sienna and light red.

31 Paint the rock to the right of the gazebo as in step 26, leaving white paper for highlights, then drop in burnt sienna and ultramarine for the darkest parts.

32 Use the no. 2 brush and cobalt blue with rose madder to shade the left-hand face of the gazebo roof.

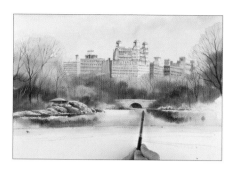

33 Prepare your washes in advance for painting the water. Use the no. 7 round brush to wet the whole area and float in the colours beneath where they appear on the land: cobalt blue and rose madder for the sky; rose madder, cobalt blue and light red for the rocks and Naples yellow and light red for the bridge.

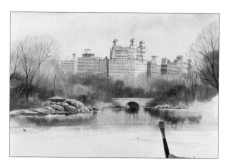

34 Add the reflection of the shadow under the bridge with burnt sienna and ultramarine. While the colours are wet, use a clean, damp 10mm (³/₈in) flat brush to drag down the reflections with vertical strokes.

35 Pick up a little white gouache on a no. 2 brush and paint ripples on the water.

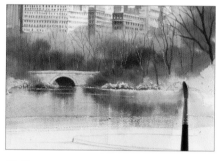

36 Create an area of rock behind the tree on the right with the no. 7 round and a wash of Naples yellow and rose madder. Allow to dry.

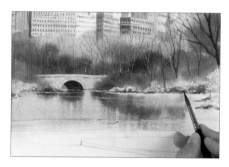

37 Add texture with the brush on its side and a mix of cobalt blue, rose madder and light red, dragged over the surface. Drop in burnt sienna and ultramarine at the water's edge. Allow to dry.

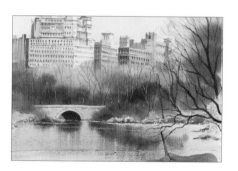

38 Paint more branches with the no. 4 brush and the same mix, then extend them with the rigger.

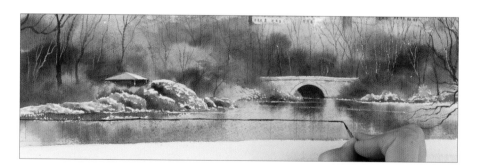

39 Remove the masking fluid from the front of the painting. Use the no. 2 brush to paint the top of the railings with burnt sienna and ultramarine.

40 Paint the main uprights, then the bottom line, then the fine railings with a fairly dry brush and rapid vertical strokes.

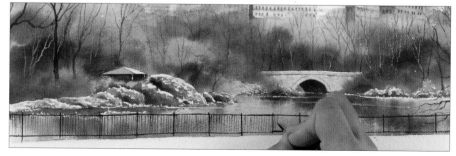

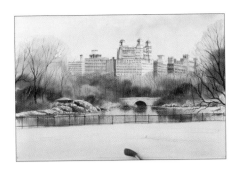

41 Apply a wash of Naples yellow and rose madder to the foreground with the no. 10 brush, using sweeping horizontal strokes. Towards the front, introduce a warmer mix of raw sienna and light red. Allow to dry.

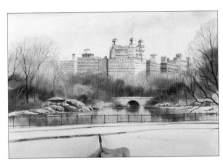

42 Paint details like the edge of the kerb with the no. 7 brush and a mix of cobalt blue, rose madder and light red, then change to a mix of burnt sienna and ultramarine to paint sharper details in shadow.

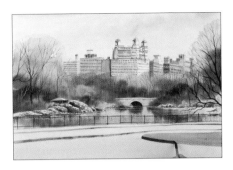

43 Apply a wash of cobalt blue, rose madder and burnt sienna to the raised area, allow it to dry, then paint the darker edge with a stronger mix of the same colours. Allow to dry.

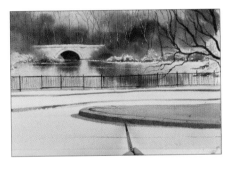

44 Paint a cast shadow from the raised area with cobalt blue and rose madder.

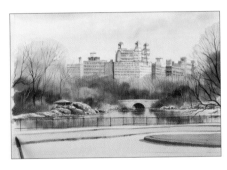

45 Make a thin wash of light red and paint the warm colour of the pavement, using the no. 10 brush. Allow to dry.

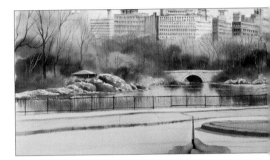

46 Using the no. 2 brush, paint details such as divisions in the paving with cobalt blue, rose madder and light red. Allow to dry.

47 Mix a wash of cobalt blue and rose madder, echoing the sky colour, and sweep a shadow across the foreground using the no. 10 brush. Use a fairly dry brush as this will help the surface of the paper to show, suggesting texture.

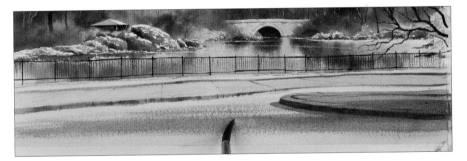

48 Use the no. 2 brush and a mix of burnt sienna and ultramarine to suggest stones in the foreground.

Overleaf

The finished painting.

23

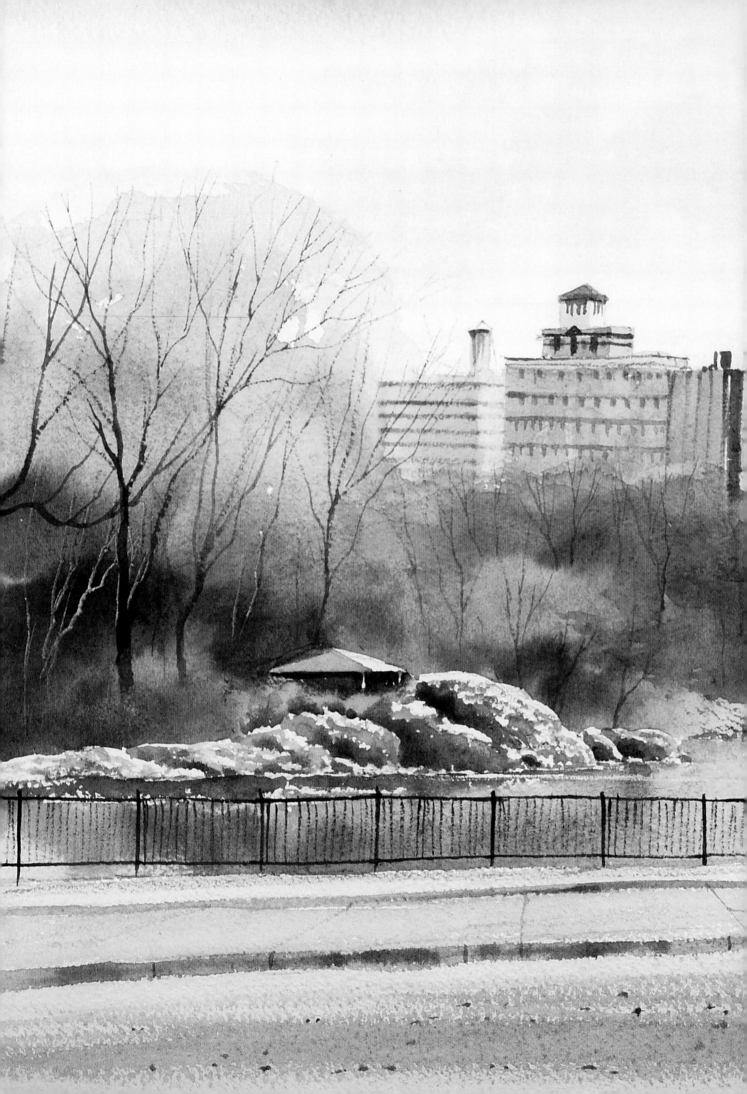

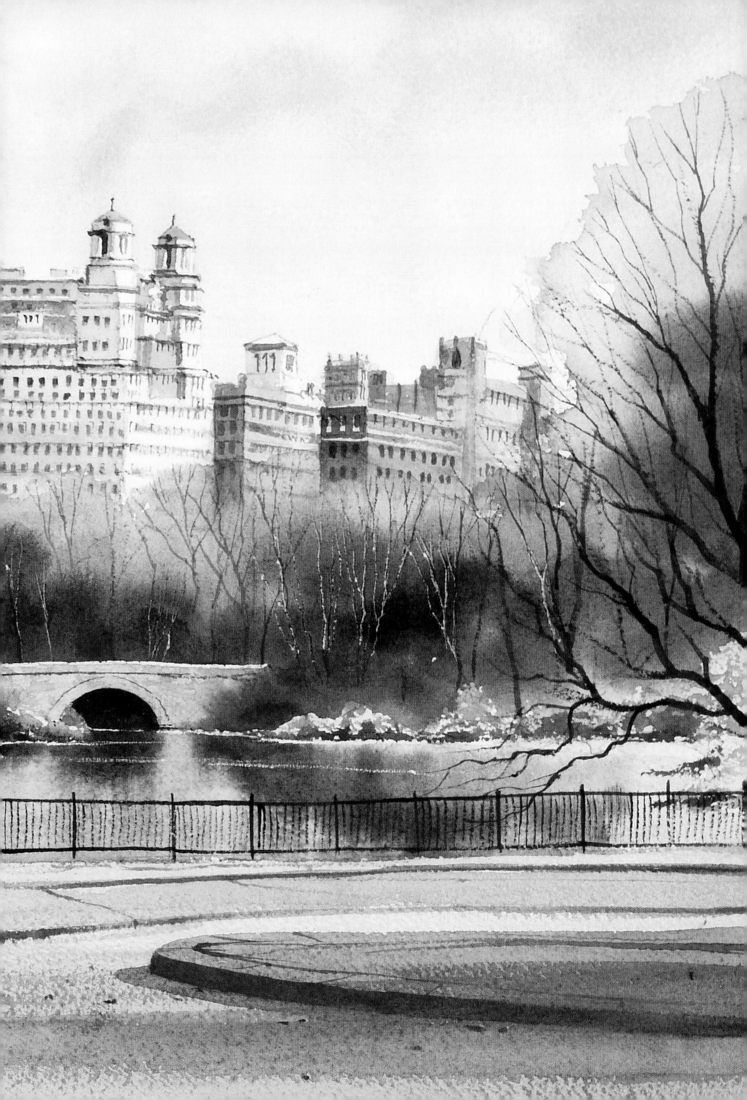

The Flatiron Building

My son, who had worked in New York, told me I ought to include the Flatiron Building, because of its unusual shape. As soon as I saw it, I was fascinated by the way its shape was designed to fit into the tight corner created by the intersection of Broadway, Fifth Avenue and 23rd Street. When it was built in 1902, it was the tallest building in the city. I could not really avoid including every window, but have treated them as simple shapes, without too much detail. It is very important to line them all up accurately both horizontally and vertically, or the structure of the building will look a bit wobbly!

You will need

300gsm (140lb) Not watercolour paper, 56 x 38cm (22 x 15in)

Colours: raw sienna, cobalt violet, cobalt blue, light red, burnt sienna, aureolin, French ultramarine, rose madder, Naples yellow, aureolin, viridian, lemon yellow, cadmium red, white gouache

Brushes: 2.5cm (1in) flat, no. 16 round, 6mm (¼in) flat, no. 7 round, no. 2 round, 3mm (⅛in) flat, no. 4 round, no. 8 round, no. 10 round

Kitchen paper

Ruler

TRACING

4

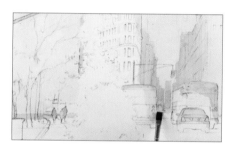

1 Mask the areas shown with masking fluid. Prepare all your sky mixes in advance. Wet the whole background with a 2.5cm (1in) flat brush and clean water, then drop in a mix of raw sienna and cobalt violet in the lower sky with the no. 16 round brush.

2 Before the paint dries, drop in a mix of cobalt blue and cobalt violet from the top of the sky, leaving a few small areas of white paper showing. Allow to dry.

3 Paint the distant buildings with the same colour mixes. Use the 6mm (¼in) flat brush to paint on cobalt blue and cobalt violet, then introduce raw sienna and cobalt violet.

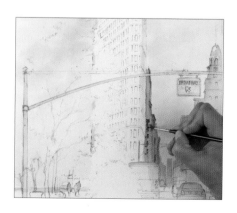

4 Continue adding form, changing to the no. 7 brush and using stronger mixes. Allow to dry, then use the no. 2 round brush and a stronger mix of cobalt blue and cobalt violet with a little light red to suggest details.

5 Use the 3mm (⅛in) flat brush to paint the sides of the buildings with the same mix.

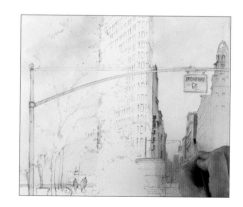

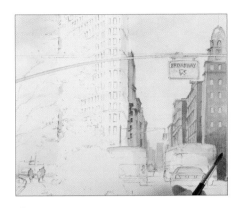

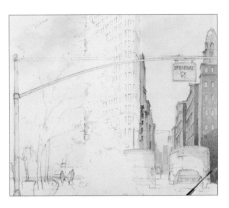

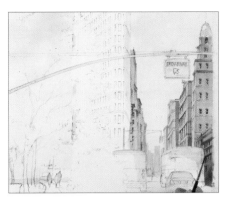

6 Paint the shadow on the right with cobalt blue and cobalt violet on the no. 7 brush, leaving spaces for windows. Add burnt sienna at the bottom.

7 While the paint is wet, drop in aureolin and cobalt blue with the no. 2 round brush to create a little greenery. Drop in a dark mix of aureolin, ultramarine and burnt sienna and allow to dry.

8 Add window details with a mix of cobalt blue, cobalt violet and burnt sienna, leaving white lines to suggest frames.

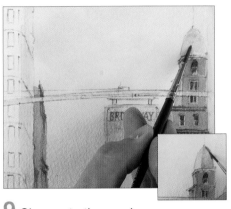

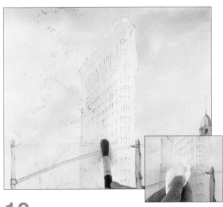

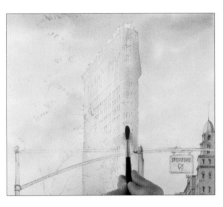

9 Change to the no. 4 brush and paint the dome with raw sienna and a little light red. Allow to dry. Add shadow to the faces of the dome with a mix of cobalt blue and rose madder. Allow one face to dry before painting the second. Paint the mast.

10 Remove the masking fluid from the Flatiron Building. Paint the whole building with a thin wash of Naples yellow and cobalt violet and the no. 16 brush. Dab with kitchen paper to create lighter areas.

11 While the paint is wet, add shadow with the no. 7 brush and cobalt blue, cobalt violet and light red. Brush the shadow colour in to merge with the background colour so that the building looks rounded. Allow to dry.

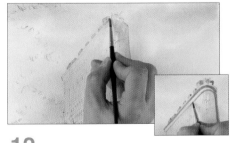

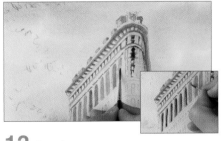

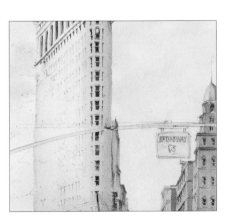

12 Paint the structure at the top of the building with the no. 4 brush and Naples yellow with cobalt violet. Develop and shade the structures with cobalt blue, cobalt violet and light red.

13 Continue suggesting structure with the no. 2 round brush. Use a stronger mix for the corner windows. Paint the arches and allow to dry, then add shadow with cobalt blue and burnt sienna.

14 Paint the corner windows with cobalt blue, cobalt violet and light red. It is easier to paint all these windows and marks in one go, to keep them in line.

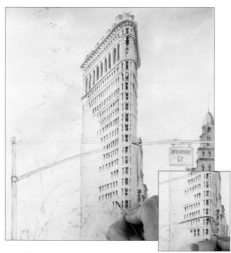

15 Continue painting the windows on the face of the building, and add the horizontal bands round the building. Add light red to the mix for one band to make it deeper.

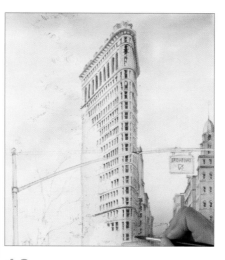

16 Use the no. 7 round brush and a mix of raw sienna and light red to suggest reflected light at the base of the building.

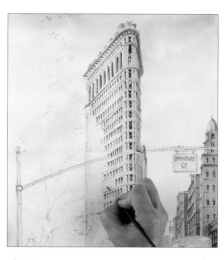

17 Paint the very fine lines on the face of the building with the no. 2 brush and a thin mix of cobalt blue, cobalt violet and light red.

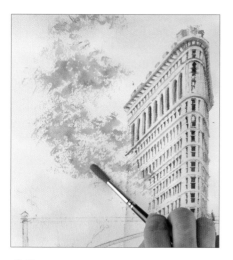

18 Prepare your mixes for the trees. Use the no. 8 brush on its side with aureolin and cobalt blue, scuffing it over the surface of the paper to suggest foliage.

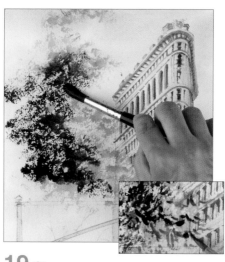

19 Change to a dark green mix of viridian, ultramarine and burnt sienna and continue painting in the same way while the bright green is wet. Use a no. 4 brush to suggest individual leaves in places.

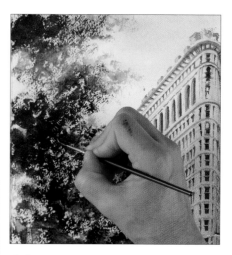

20 Continue adding bright and dark green, then use the no. 2 brush and neat lemon yellow to paint some bright leaves against dark areas.

21 Using the no. 8 brush and raw sienna with light red, suggest the shapes of buildings behind the trees. Drop in cobalt blue and cobalt violet and allow to dry.

22 Use the no. 4 brush and burnt sienna with ultramarine to suggest dark details.

23 Paint a vague suggestion of the buildings that will be behind the trees with raw sienna and light red, then cobalt blue and cobalt violet, using the no. 8 brush.

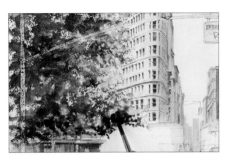

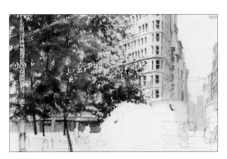

24 Add bright green to the trees with the no. 10 brush and aureolin with cobalt blue. Drop in the dark green mixed from viridian, ultramarine and burnt sienna. Add touches of lemon yellow with the no. 2 round brush.

25 Work on the tree to the right of the main group in the same way. Add plenty of the dark green so that it will stand out against the brighter bush to be painted later.

26 Rub off the masking fluid from the base of the buildings and the figures. Paint the smaller tree trunks with the no. 4 brush and ultramarine with burnt sienna.

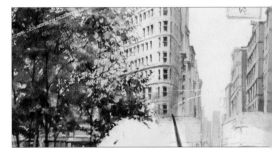

27 Paint the nearest of the tree trunks with Naples yellow and cobalt violet for the lighter left-hand side, then shade the darker side with burnt sienna and ultramarine. Paint the lighter side with neat Naples yellow to blend the shades.

28 Use the no. 2 round brush and the burnt sienna and ultramarine mix to paint branches where they appear against the sky and lighter foliage.

29 Remove the masking fluid from the traffic light and its support. Wet the area behind the bus with clean water and use cobalt blue, cobalt violet and light red on the no. 4 brush to add colour to the building so that it will contrast with the bush.

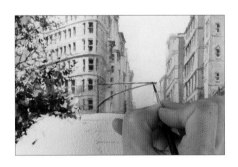

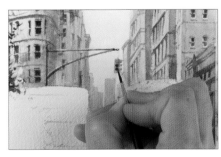

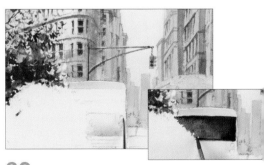

30 Allow to dry and rub the masking fluid off the bus. Paint the traffic light support with the no. 2 round and a thick mix of cobalt blue, cobalt violet and light red, leaving a white line for highlights.

31 Paint the main body of the traffic light with lemon yellow and light red, and shade it with the grey from the previous step. Paint the red light with cadmium red and the others with a mix of burnt sienna and ultramarine, and the cable in grey.

32 Prepare all the mixes you will need for the bus. Paint the top and bottom with pale grey mixed from cobalt blue, cobalt violet and light red, and soften this in with water. Paint the back window with a dark mix of burnt sienna and ultramarine on the no. 4 brush, then float in the pale grey while this is wet.

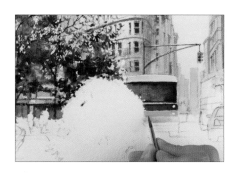

33 Paint the blue band with ultramarine and a touch of burnt sienna, leaving a tiny white stripe and a circle for the back light. Then paint the yellow band with lemon yellow and light red.

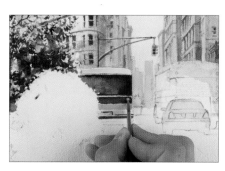

34 Paint the bumper details with the same blue as the band, then paint the back light with cadmium red and lemon yellow.

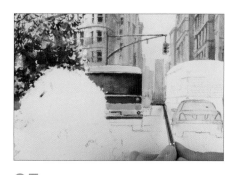

35 Remove the masking fluid from the road and the other bus, but leave it on the taxi. Darken the lower part of the distant buildings with grey (cobalt blue, cobalt violet and light red) to highlight the road.

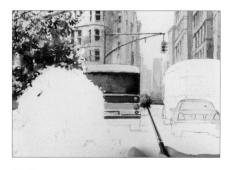

36 Paint the bush between the buses with aureolin and cobalt blue, then add the dark green mixed from viridian, ultramarine and burnt sienna, and touches of lemon yellow.

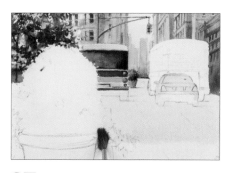

37 Paint the distant plant pot with Naples yellow and light red, then shade it with grey mixed from cobalt blue, cobalt violet and light red. Use the no. 7 round to paint clear water over the road, then introduce Naples yellow and light red.

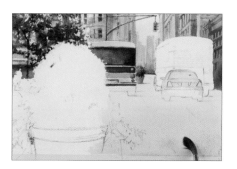

38 In the foreground, add raw sienna and cobalt violet to the wash. Complete the road on the left of the foreground bush in the same way.

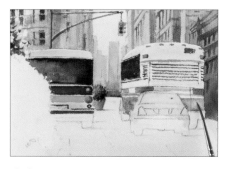

39 Use the no. 2 brush to paint the details of the right-hand bus, with light grey mixed from cobalt blue, cobalt violet and light red, then a band of cobalt blue and lemon yellow. Paint the window with burnt sienna and ultramarine, and float in light grey. Then use the dark mix to paint the grid lines. Use cadmium red and lemon yellow for the lights.

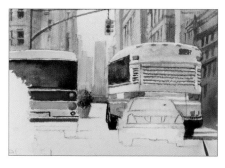

40 Shade the back of the bus with cobalt blue and cobalt violet so that the side looks sunlit. Allow to dry. Paint the darks under the bus with burnt sienna and ultramarine, and add a cast shadow with cobalt blue and cobalt violet.

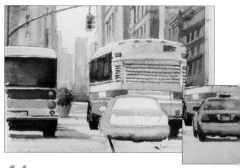

41 Remove the masking fluid from the taxi and paint it in lemon yellow and light red. While this is wet, paint the underside in burnt sienna and ultramarine so that the colours merge. Paint other dark details with the same mix, the lights in cadmium red and the shadow with cobalt blue, cobalt violet and light red. Paint the window as for the buses. Add a cast shadow as for the bus.

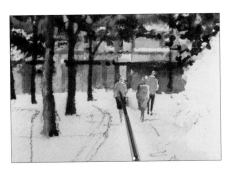

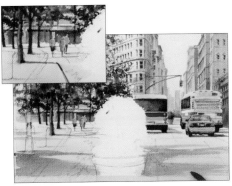

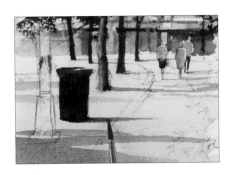

42 Paint the left-hand figure with a cadmium red sweater, an ultramarine skirt and lemon yellow and light red legs. Paint the man in cobalt blue with traces of white left at the edges where he catches the light, and trousers in ultramarine and burnt sienna. The third figure can have a cobalt violet dress.

43 Paint cast shadows from the figures and trees in cobalt blue and cobalt violet, then change to the no. 10 round brush and paint shadows across the foreground with cobalt blue, cobalt violet and light red.

44 Use burnt sienna and ultramarine to paint the litter bin and add a shadow with cobalt blue, cobalt violet and light red.

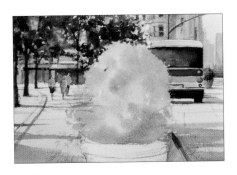

45 Paint the bush in the foreground planter with lemon yellow and the no. 10 brush. Drop in aureolin and cobalt blue while the first wash is wet.

46 Drop in a dark green mix of viridian, ultramarine and burnt sienna while the paint is wet.

47 Using the no. 7 round, add more of the bright green and soften it in. Extend the greens over the edge of the planter, then add dashes of lemon yellow to break up the dark areas and suggest brightly lit leaves.

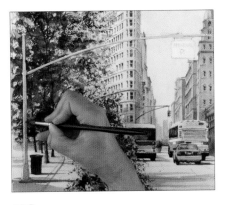

48 Paint the planter with Naples yellow and drop in a touch of light red. On the shaded side, use the no. 4 round to drop in cobalt blue, rose madder and light red. Allow to dry.

49 Paint the rim of the planter with the same shadow colour. Add overhanging foliage using the same mixes as in steps 45 to 46, then add cast shadows from the foliage using the shadow mix.

50 Remove the masking fluid from the sign support. Paint the pole with a wash of cobalt blue, cobalt violet and light red, leaving a white line for highlight on the left of the upright pole and at the top of the horizontal bar. Add a cast shadow with the same mix.

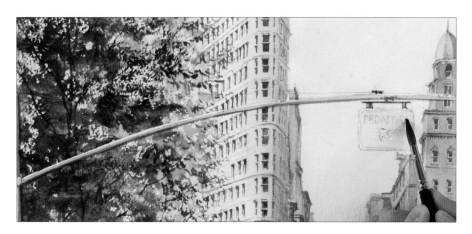

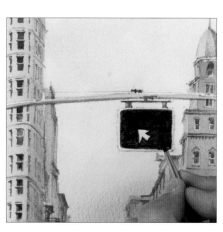

51 Shade the underside of the horizontal bar with the same mix, and paint the details of the structure supporting the sign.

52 Paint the dark green of the sign with the no. 4 brush and a mix of viridian, ultramarine and burnt sienna, leaving the arrow white. Allow to dry.

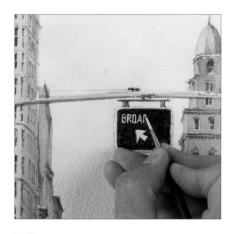

53 Paint the lettering with white gouache and a little cobalt violet on the no. 1 round brush.

54 Paint the cable supporting the sign with the same opaque mix, using a ruler to help you. Hold your fingers under the top edge of the ruler so that the ferrule, rather than the brush itself, runs along the ruler.

55 Paint the cable where it passes over a light background with cobalt blue, cobalt violet and light red.

Opposite

The finished painting, reduced in size.

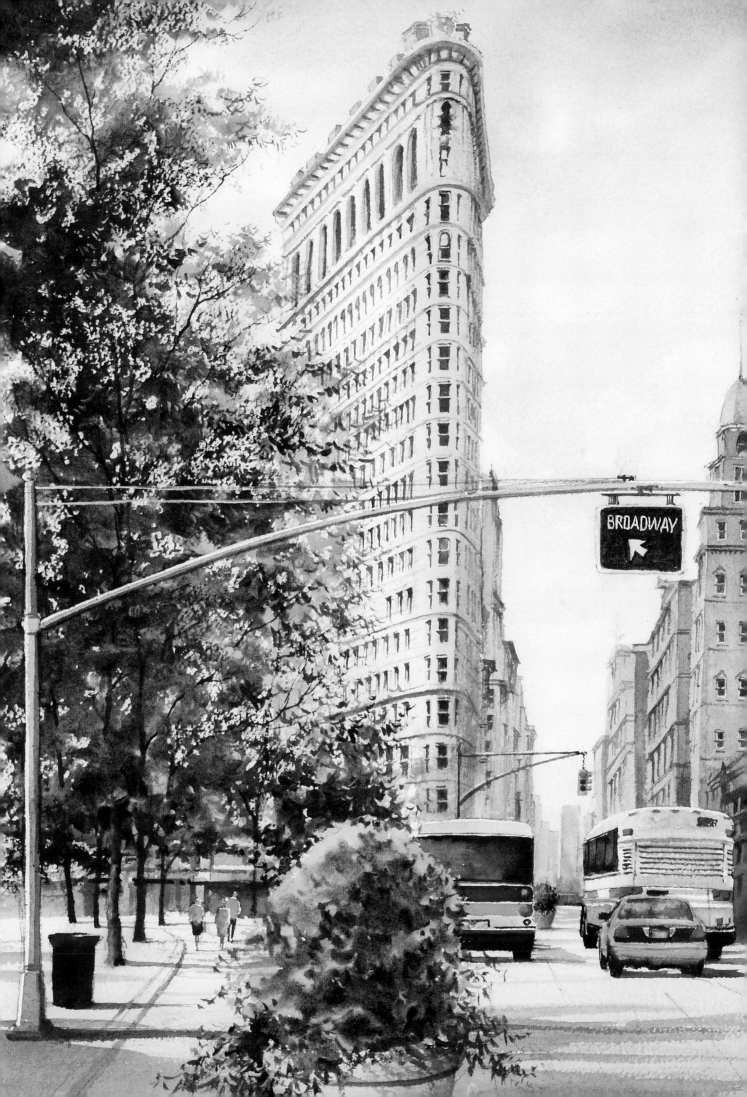

The Empire State Building

This is probably best-known building on the New York skyline, at 350 Fifth Avenue between 33rd and 34th streets. I like the way it gradually narrows to just a spire. The panorama from the viewing platform on the eighty-sixth floor really is breathtaking.

Again, the soft shapes of the trees, rendered in rich summer green, contrast well with the hard edges and red brickwork of the surrounding buildings.

Washes applied at the beginning of the painting process should create a simple but effective glowing sky. It is important to keep the lines of the buildings crisp and straight against this background, so I have used masking tape to achieve good, sharp edges.

TRACING 5

You will need

300gsm (140lb) Not watercolour paper, 56 x 38cm (22 x 15in)

Colours: quinacridone gold, light red, rose madder, cobalt blue, Naples yellow, burnt umber, burnt sienna, raw sienna, French ultramarine, cadmium red, aureolin, white gouache, viridian, lemon yellow

Brushes: large mop, 2.5cm (1in) flat, no. 10 round, no. 2 round, 3mm (¹⁄₈in) flat, 6mm (¼in) flat, no. 4 round, no. 7 round, no. 8 round

Masking fluid and old brush

Masking tape

Ruler

Sponge

Tip

Practise applying and removing masking tape on the same kind of paper before using it on your painting, to avoid accidents.

1 Wet the whole painting with clear water and a large mop brush, then use a 2.5cm (1in) flat brush to paint a unifying wash of quinacridone gold and light red over the whole painting. Drop in a wash of rose madder, then a mix of cobalt blue and rose madder at the top. Allow to dry.

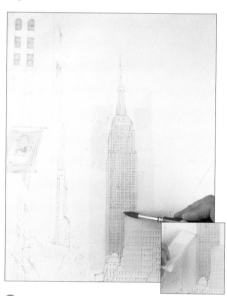

2 Paint masking fluid over the windows of the left-hand building and the banner. Mask the edges of the Empire State Building with carefully applied masking tape. Rub the tape with a fingernail to ensure that it is securely attached, otherwise paint will seep in. Using the no. 10 round brush, paint on a wash of Naples yellow and burnt umber. Drop in a little light red lower down. Allow to dry thoroughly and carefully peel off the masking tape.

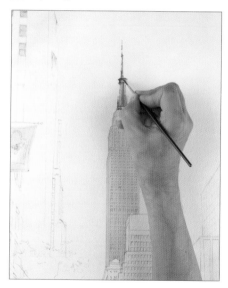

3 Mix a grey from cobalt blue, rose madder and light red and use the no. 2 brush to paint details at the top of the building. Add shape using a darker version of the same mix.

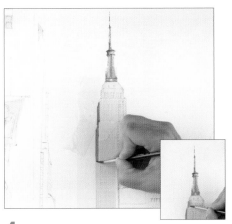

4 Mask the edge of the shadowed left-hand side of the building, as before, using masking tape. Paint the shaded edge with the grey mix. Allow to dry and remove the masking tape. Shade the left-hand top of the building by hand and fade off the shadow with clean water.

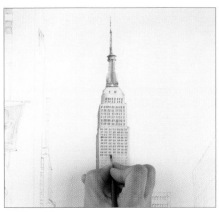

5 Use the 3mm (¹⁄₈in) flat brush and the same grey to paint the windows with little vertical strokes.

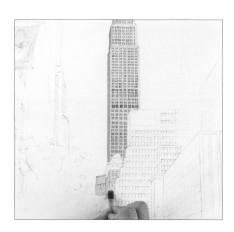

6 Change to a 6mm (¹⁄₄in) flat brush and block in the buildings in front of the Empire State Building with a mix of Naples yellow, light red and burnt sienna.

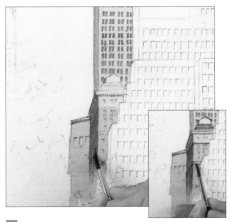

7 Paint the top of the building with Naples yellow and a hint of rose madder, using the no. 4 round brush. Allow to dry, then add shadow with the grey mix of cobalt blue, rose madder and light red. Pick out architectural details with a stronger mix of the same colours.

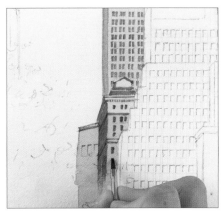

8 Use the 3mm (¹⁄₈in) flat brush to paint the windows.

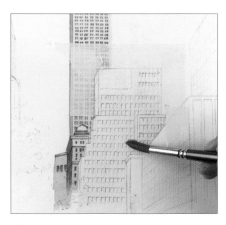

9 Use masking tape to mask the edges of the rectangular building. Mix Naples yellow with a little quinacridone gold and use the no. 10 brush to paint the building. Drop in a little rose madder before it dries. Allow to dry. Carefully remove the masking tape.

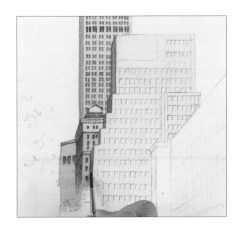

10 Shade the left-hand side of the building with the shadow mix.

11 Allow to dry. Apply masking tape to the top and bottom of the area of long windows. Use burnt umber and the 3mm (¹⁄₈in) flat brush on its side to paint the windows carefully. Allow to dry and carefully remove the masking tape.

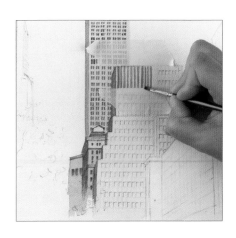

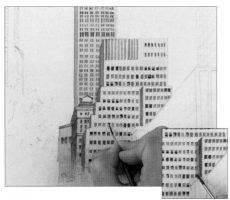

12 Use the same brush and mix to paint the windows at the top. Then use the no. 2 brush and the grey mix to paint the lower windows with quick, vertical strokes. Make some darker than others. Add a cast shadow with a thinner mix.

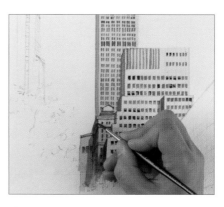

13 Add cast shadows on the other buildings.

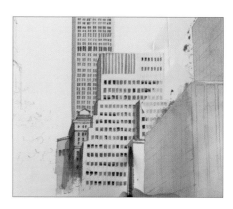

14 Mask the edges of the foreground building with masking tape. Use the no. 10 brush and a mix of cobalt blue, rose madder and light red to paint it. Use a paler mix for the lit face. Paint the left-hand part that juts out, leaving one side white.

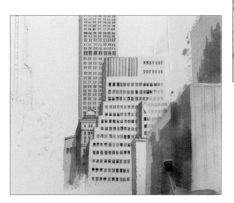

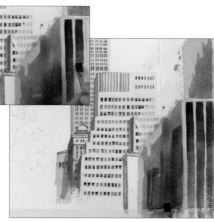

15 Use a stronger mix of the same grey on the 6mm (¼in) brush to suggest reflections in the right-hand building. Brush in a mix of burnt umber and cobalt blue while the paint is wet.

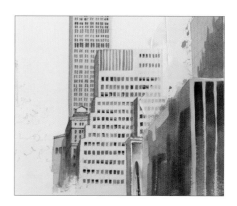

16 Use the same brush and the burnt umber and cobalt blue mix to paint the long windows on the far right, then add more dark reflections.

17 Paint the face of the part of the building that juts out with the grey mix of cobalt blue, rose madder and light red, on the no. 4 round brush, then drop in a mix of Naples yellow and quinacridone gold to suggest reflections.

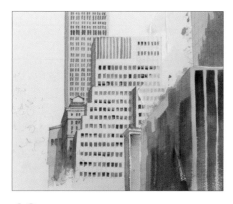

18 Add more of the same mix to the reflections on the main part of the building. Allow to dry and remove the masking tape.

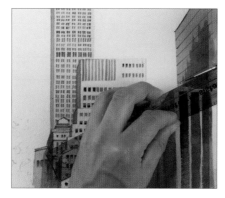

19 Paint the grid of window frames using a ruler to help you, the no. 2 brush and a mix of burnt umber and cobalt blue.

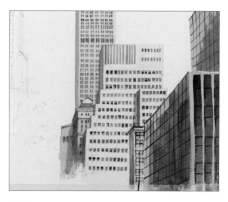

20 You may need to reinforce the pencil lines from the tracing if they are under layers of paint. Continue painting windows freehand.

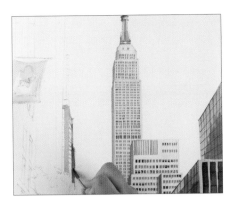

21 Paint the bright building on the left with the no. 7 round brush and a mix of raw sienna and light red, leaving white gaps, then paint in the building behind it with grey mixed from cobalt blue, rose madder and light red, down to where it will be lost in the trees.

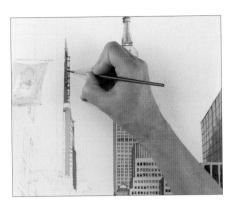

22 Higher up, paint on more raw sienna and light red, then drop the grey mix into it. Change to the no. 2 round brush and suggest the fire escape with fine lines and not too much paint.

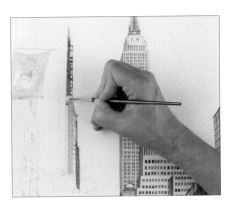

23 Paint the little yellow section with Naples yellow and quinacridone gold.

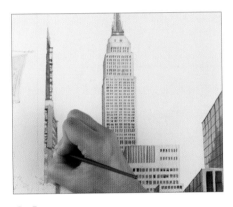

24 Mix Naples yellow with light red to paint some redder bricks. Suggest window frames with a mix of burnt umber and cobalt blue, then paint the window panes with Naples yellow and quinacridone gold. Allow to dry.

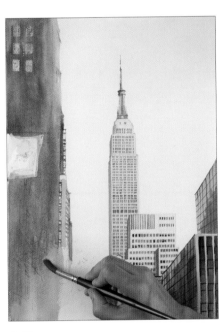

25 Take the no. 8 round brush and begin to paint the left-hand building with Naples yellow and light red, then drop in burnt umber. Paint with broad, vertical strokes, over the masking fluid. Fade out at the bottom with clear water, ready for the tree.

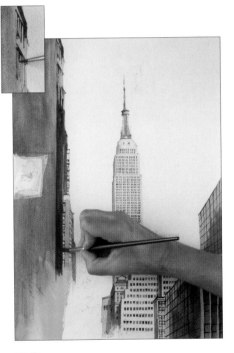

26 Use the no. 4 round brush and burnt umber and cobalt blue to suggest detail on the right-hand side. Change to the no. 8 round brush and paint the dark side of the building where it is shadowed by other buildings.

27 Still using the burnt umber and cobalt blue mix, suggest texture by using the 6mm (¼in) flat brush, fairly dry, and dragging it with horizontal strokes over the building.

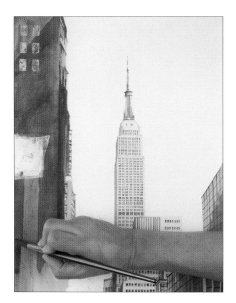

28 Take the no. 10 round brush and a mix of cobalt blue, rose madder and light red and glaze this shadow mix over the building, beginning with a diagonal at the top and leaving a long gap at the bottom to suggest another building in front. Allow to dry.

29 Use the same shadow mix with the 3mm (⅛in) flat brush to suggest stonework in the wall. Do not make too many marks.

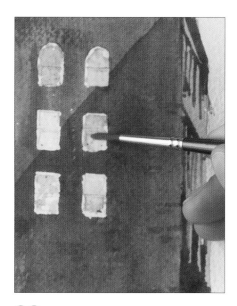

30 Remove the masking fluid from the windows. Use the no. 4 round brush with a mix of cobalt blue and rose madder for the window panes, dropping in clean water to give the impression of glass. Allow to dry.

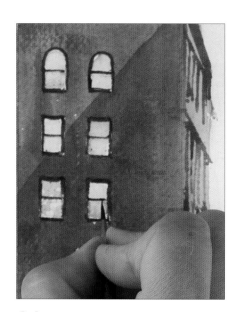

31 Paint the window frames with the no. 2 round brush and ultramarine with burnt umber.

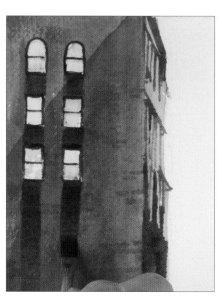

32 Mix burnt umber and cobalt blue and use the 6mm (¼in) flat brush to paint the dark stripes down the building.

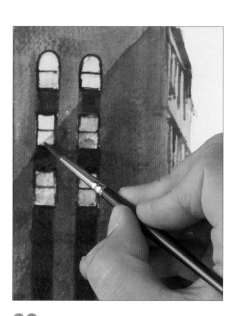

33 The diagonal shadow that crosses the building should affect the windows too, so shade them with a mix of cobalt blue and rose madder with the no. 4 round brush.

34 Use the dark mix of ultramarine and burnt umber to paint the windows on the foreground building, which are at an extreme angle because of perspective.

35 Paint the edge of the banner with cadmium red with a touch of the grey mix.

36 Paint the yellow part of the banner with aureolin mixed with light red and a tiny touch of grey.

37 Return to the red mix for the centre of the banner.

38 Change to the no. 2 round brush and use a mix of burnt umber and ultramarine to paint the black lines. Allow to dry.

39 Change to the no. 8 brush and paint shadow over the banner with cobalt blue, rose madder and light red.

40 Paint the pole with white gouache with a little of the grey mix added.

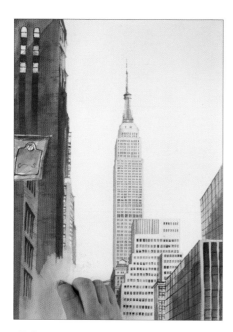 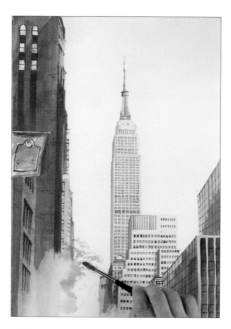 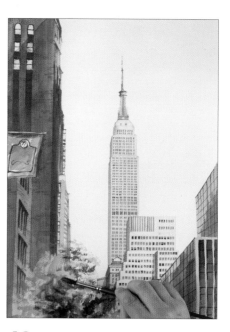

41 Soften the area where the tree will go with a damp sponge, to remove any hard lines.

42 Mix your tree greens in advance. Use the no. 7 brush to paint on the bright green mixed from aureolin and cobalt blue, using the brush fairly dry and on its side.

43 While the paint is wet, change to the no. 8 brush and paint on a dark green mixed from viridian, ultramarine and burnt sienna, building up the foliage.

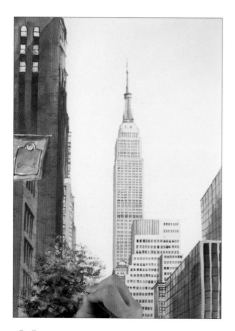

44 Use the no. 2 round brush to paint lemon yellow on top of the dark areas, suggesting bright foliage.

45 Paint the branches visible through the foliage with burnt umber and ultramarine.

Opposite

The finished painting, reduced in size.

40

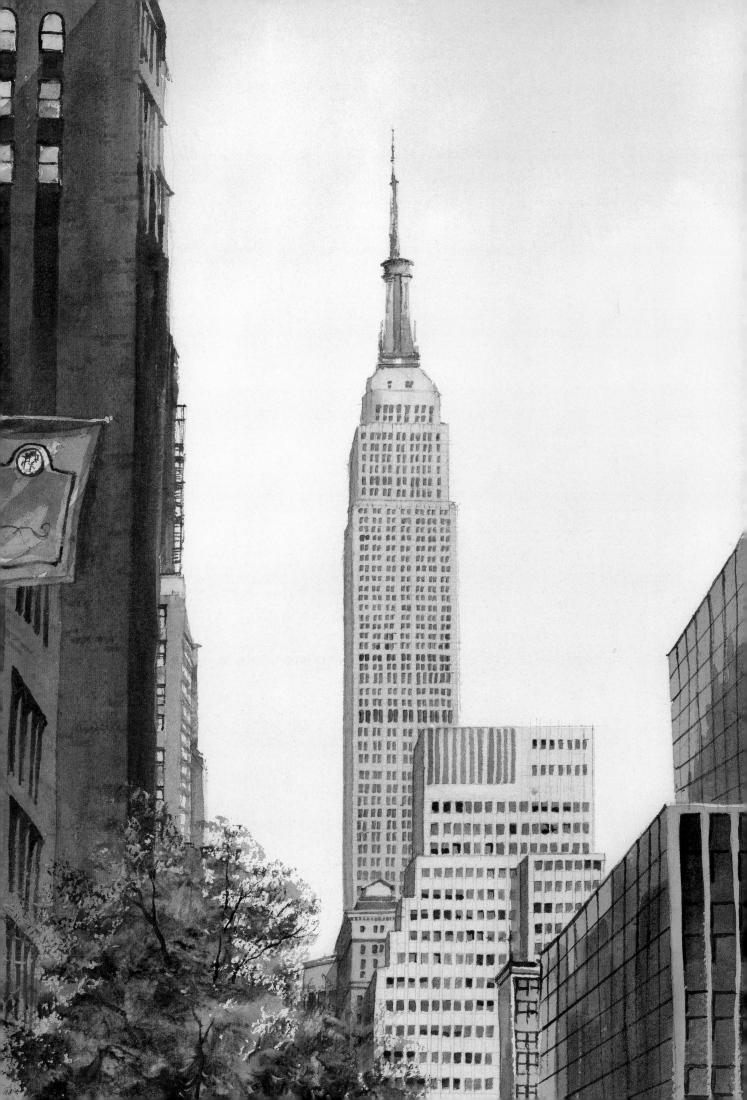

The Statue of Liberty

I took numerous photographs of the Statue of Liberty from the Staten Island Ferry, both on the outward and return journey. Unfortunately it was a dull afternoon that got progressively duller, with quite a bland, uninteresting sky. However, I got enough information to create this painting and used my imagination to make a more appealing scene. I chose to drop a hint of rose madder into the upper and lower part of the sky to provide a rich contrast with the verdigris on the statue itself. This hint of warm red continues on to the plinth and sea wall.

Not being a portrait artist, I found the statue's face the hardest part to draw. You should find the tracing useful for this!

TRACING
6

You will need

300gsm (140lb) Not watercolour paper, 56 x 38cm (22 x 15in)

Colours: Naples yellow, rose madder, cobalt blue, neutral tint, cobalt turquoise, cobalt violet, burnt sienna, white gouache, raw sienna, light red, French ultramarine, aureolin, viridian, lemon yellow, cadmium red

Brushes: 2.5cm (1in) flat, no. 16 round, no. 2 round, no. 4 round, no. 1 round, no. 8 round, 6mm (¼in) flat, no. 10 round

Masking fluid and old brush

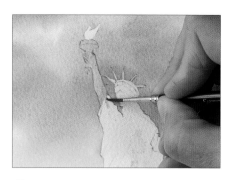

1 Mask the edges of the statue and plinth, the water's edge and the flag. Prepare your washes in advance. Use a 2.5cm (1in) flat brush to wet the paper down to half way down the trees. Use the no. 16 round brush to drop in a wash of Naples yellow and rose madder at the bottom of the sky.

2 Paint a wash of cobalt blue and rose madder from the top of the sky before the first wash is dry, leaving gaps for clouds.

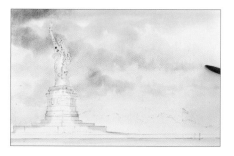

3 Still working on a wet background, make marks for clouds with a mix of neutral tint and rose madder. Make the marks darker at the top and smaller towards the horizon to create perspective. Allow to dry.

4 Remove the masking fluid from the plinth and statue. Prepare your washes in advance for the statue. Use the no. 2 brush to paint a watery wash of cobalt turquoise from the top of the statue.

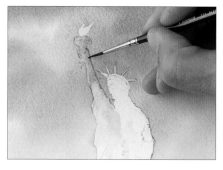

5 Fade the bottom edge with clean water to avoid hard edges forming. Shade the right-hand side with a mix of cobalt blue, cobalt violet and a hint of burnt sienna, and allow to dry.

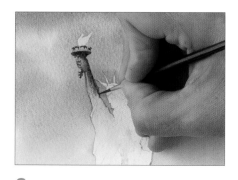

6 Paint the underside of the torch with the same shadow mix, and continue suggesting detail.

7 Use a stronger mix of cobalt turquoise to paint the creases in the drapery. Add shadow with cobalt blue and cobalt violet.

8 Paint the rest of the statue with the no. 4 round brush and the pale cobalt turquoise wash and allow it to dry.

9 Use the no. 2 brush again and a mix of cobalt blue, cobalt violet and burnt sienna to form the chin. Since you are working with shadow, fade some of the edges at each stage with clean water. Continue forming the face and head details.

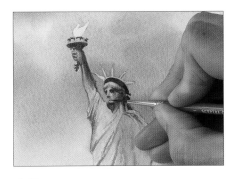

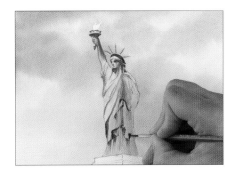

10 Change to the no. 1 round brush to paint the finer details of the face.

11 Paint the shadowed sides of the spikes of the headdress, leaving white paper as highlights.

12 Continue painting the folds in the drapery with the cobalt blue and cobalt violet mix, then, for darker shadows, use cobalt blue, cobalt violet, burnt sienna and a little cobalt turquoise.

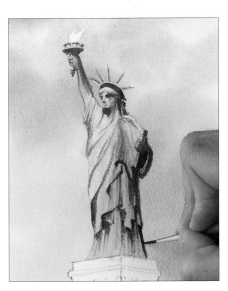
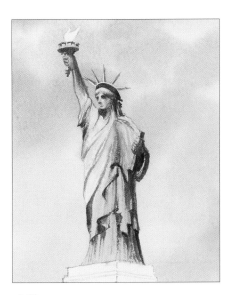

13 Suggest the hand holding the book, then paint the dark shadow on the right-hand side that highlights the book itself.

14 Add more burnt sienna and cobalt blue to the mix to paint the richest, darkest shadows.

15 Mix white gouache with a little cobalt turquoise and paint highlights on the hair, eye, book and drapery using the no. 1 round brush.

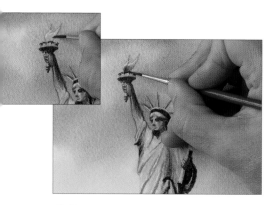
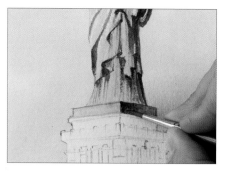
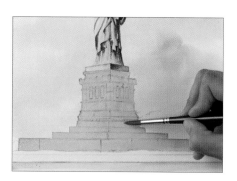

16 Mix raw sienna and light red and paint the golden flame. Paint the dark under the flame with burnt sienna and ultramarine.

17 Paint the top of the plinth with the thin cobalt turquoise wash and the no. 2 round brush, and allow it to dry. Add shadow with cobalt blue, cobalt violet, burnt sienna and a little cobalt turquoise.

18 Paint the rest of the plinth with the no. 8 round brush and a mix of Naples yellow and rose madder. Allow to dry.

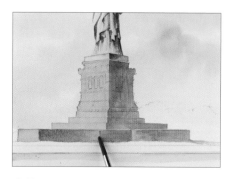
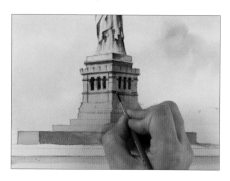
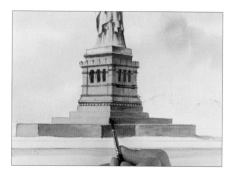

19 Paint the shaded side of the plinth with cobalt blue and rose madder. Fade parts of the base that are less dark with clean water.

20 Begin to paint the detail of the plinth with the no. 1 brush and a mix of cobalt blue, rose madder and burnt sienna.

21 Darken the shadows on the plinth further with the no. 4 round brush and a mix of cobalt blue, rose madder and burnt sienna. Make the shadows darkest where they meet the light. Allow to dry.

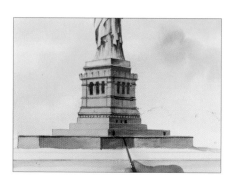

22 Use the no. 1 brush and a dark mix of ultramarine, burnt sienna and rose madder to paint the dark details of the plinth and the shade under the rim.

23 Add texture using the same mix and the 6mm (¼in) flat brush. Drag the fairly dry brush over the surface of the paper.

24 Thin down the mix a little and add texture to the sunlit part of the plinth, dragging the brush down.

25 Prepare the washes for the trees. Use the no. 10 brush and a bright green mix of aureolin and cobalt blue to paint the trees. While this is wet, drop in viridian, ultramarine and burnt sienna.

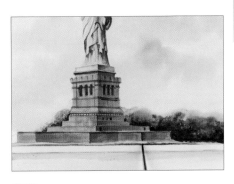

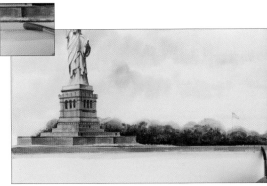

26 Continue adding more light green, then more dark at the bottom, merging the colours while they are wet. Add touches of lemon yellow on the no. 2 round brush to suggest individual highlit leaves. Paint the trees to the left of the plinth in the

27 Paint the grass under the plinth with aureolin and cobalt blue on the no. 4 round brush. Add the dark green at the bottom.

28 Mix Naples yellow and rose madder to paint the wall at the water's edge, using the no. 8 brush. Allow to dry. Use a dry no. 4 round loaded with cobalt blue, rose madder and burnt sienna, to create texture, leaving a thin line of highlight at the top.

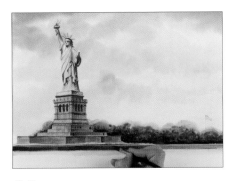

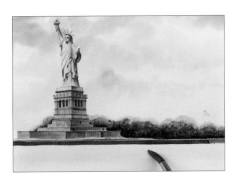

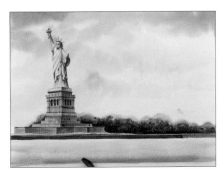

29 Allow to dry, then repeat the texturing process with a darker mix of the same colours on the 6mm (¼in) flat brush.

30 Prepare your washes for the water in advance. Rub off the masking fluid from the water's edge. Use the no. 16 round brush to wet the water area, leaving a thin, dry line under the wall. Drop in Naples yellow and rose madder at the top.

31 Introduce cobalt blue and rose madder half-way down, then at the bottom, paint horizontal strokes of neutral tint and rose madder. Allow to dry.

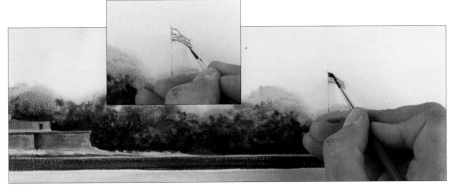

32 Use the no. 8 brush to add horizontal strokes of cobalt blue and rose madder for ripples, then add neutral tint ripples at the front in the same way.

33 Remove the masking fluid from the flag and paint the stripes with the no. 1 brush and cadmium red, and the blue part with ultramarine, then paint the pole with ultramarine and burnt sienna.

Overleaf

The finished painting.

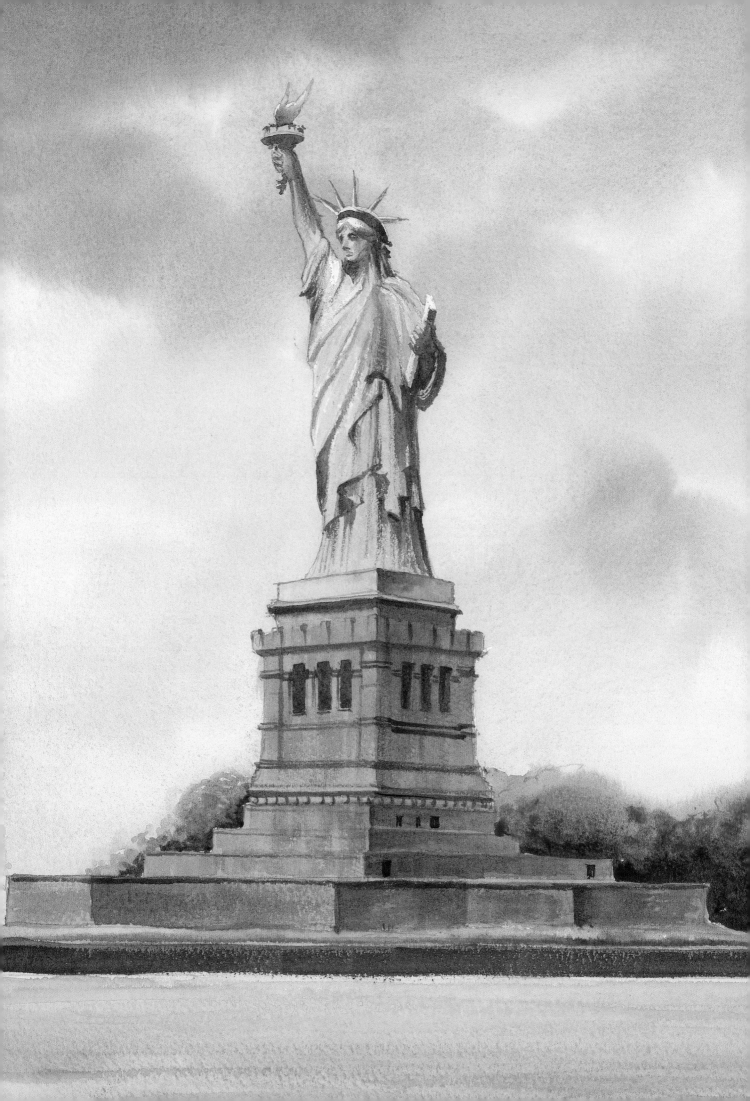

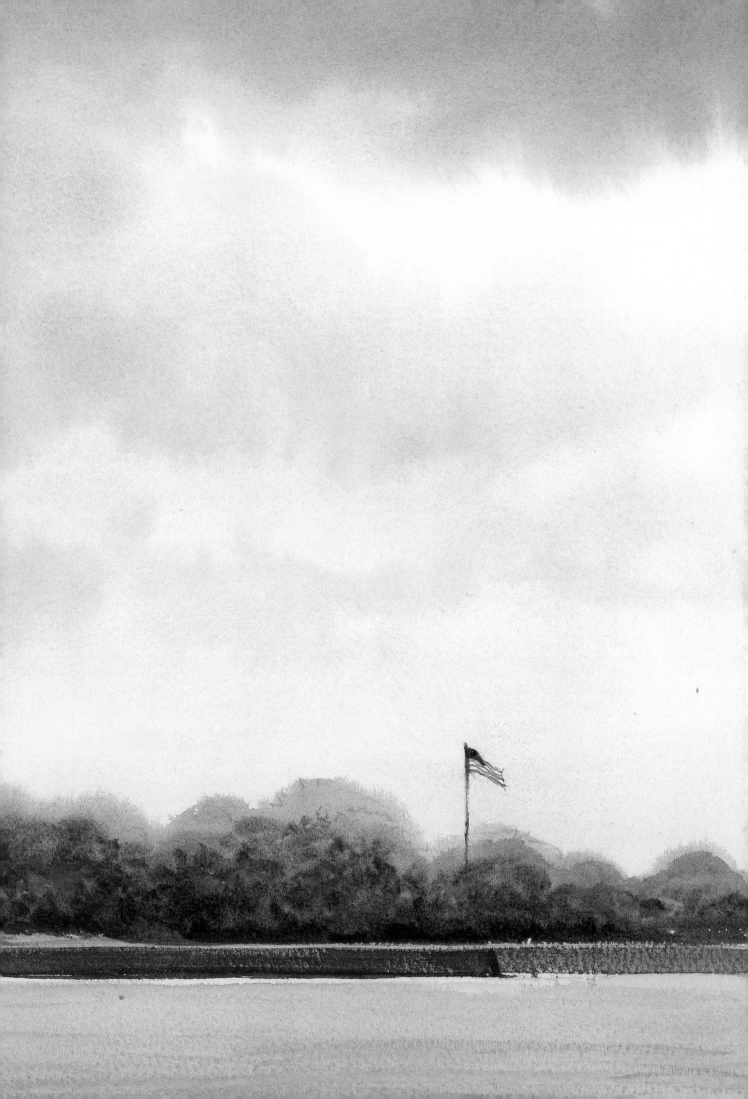

Index

Central Park in Snow

48 x 32cm (19 x 12⁵/8in)

This could be described as a painting of two halves, with almost a traditional rural landscape in the middle distance and foreground, featuring a bridge, reflections, skeletal winter trees and a dense wooded area. Then these are contrasted with the slab-like, enormous sky scrapers in the distance. I deliberately rendered these in light, cool greys to push then into the distance, introducing warmer reds and browns into the middle distance, on the bridge itself and in the reflections in the river. I used a limited palette of light red, cobalt blue, burnt sienna, raw sienna and rose madder, with a few light touches of opaque white to add some snow highlights.

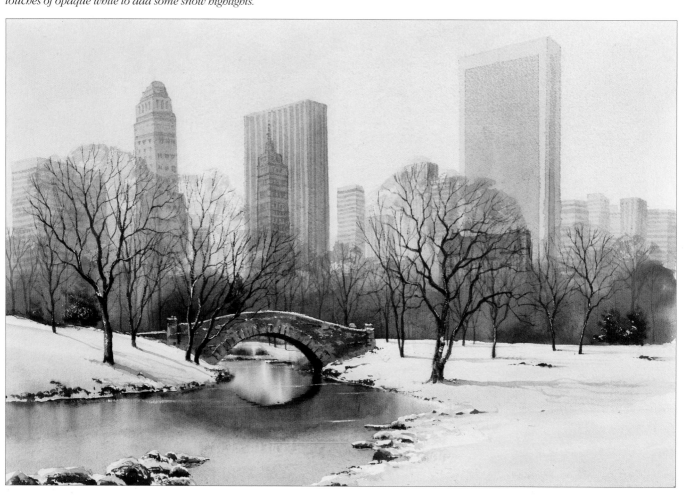